SOUTH SHIELDS

THROUGH THE AGES

Caroline Barnsley

AMBERLEY PUBLISHING

For Dave and Harry and my grandchildren, in time...

First published 2015

Amberley Publishing
The Hill, Stroud, Gloucestershire, GL5 4EP
www.amberley-books.com

Copyright © Caroline Barnsley, 2015

The right of Caroline Barnsley to be identified
as the Author of this work has been asserted in
accordance with the Copyrights, Designs and
Patents Act 1988.

ISBN 978 1 4456 4107 2 (print)
ISBN 978 1 4456 4116 4 (ebook)

British Library Cataloguing in Publication Data.
A catalogue record for this book is available from
the British Library.

Typesetting by Amberley Publishing.
Printed in the UK.

INTRODUCTION

I am delighted to be able to endorse this second well-researched book by our talented local historian and librarian, Caroline Barnsley. Building on the success of her previous book, Caroline again provides us with the opportunity to celebrate the history and development of South Shields with a particular emphasis on the settlement close to the River Tyne, including the establishment of the fort built by the Roman Army in AD 160, the customs house and Harton Staithes. It is the riverside regeneration scheme that, as Caroline says, is now forging a new relationship for the people of the town with the river.

This fascinating selection of postcards and old photographs is greatly enhanced by the fantastic photographic skills of Dave Barnsley. The undoubted highlight for me is the magical image of Irene Brown's 2004 stainless steel sculptures of seventeenth-century collier brigs at Market Dock, an area not usually on the tourist trail but which was at the heart of our maritime heritage. Countless ships were built and launched from this very dock, serving an extensive international market. Caroline and Dave even show that some seemingly unattractive landmarks, such as the restored gasometer during twilight, has a certain beauty.

It was the market that was seen by generations of folk from South Shields as the centre of the town. The old town hall was the base of the first town centre library over 200 years ago, and it is with this in view that the new library and community hub for South Tyneside is being built. Caroline provides an interesting insight into the development of the libraries and museum. Her wry sense of humour is particularly evident when she relates the story of the relocation of the golden lion from the former public house in King Street to the museum forecourt. The lion is no longer golden but it appears that he never was, as his tongue was green!

Caroline's abiding love of animals is again evident from her moving stories about South Shields very own 'Wandering Willie', the Guinness menagerie which describes the emblematic symbol of the toucan and finally to the local seagulls of which she talks affectionately, although they are considered by many of the town to be a scourge.

Caroline engages with the reader through her clever selection of images, supported by a miscellany of facts embedded in a concisely written text. A variety of techniques are employed; sometimes information is presented in chronological order, elsewhere there are titbits encouraging the reader to look further. This is especially true in Caroline's use of potted biographies of some famous and yes, infamous, people of the town: Amy Flagg, Dolly Peel, Isaac Cookson, Robert Darling (nephew of Grace), Sir William Fox, King Neptune (Bill Lodge) and Giuseppe Valenti of Minchella Ice Cream Parlour to name but a few.

With the publication of two books in two years, Caroline has already made an important contribution to our knowledge of our beloved town. I hope she can continue in her endeavours.

Heather V. Thomas
2015

ACKNOWLEDGEMENTS

The archive material in South Tyneside Central Library has proved an indispensable resource for this publication. Special thanks to Dave Barnsley, Ken Lubi, Len Ball, Alec Jones, Gill Jackson and Mick Ridley for kind permission to use their images.

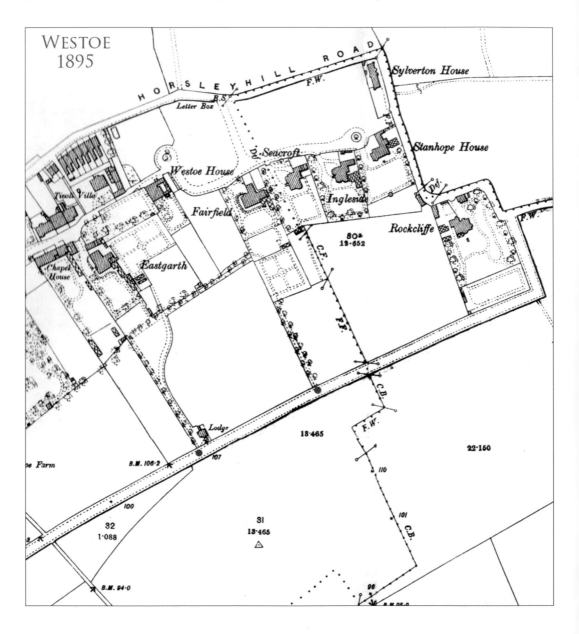

Old Town Hall

By the early part of the eighteenth century, Shields was a large village noted as a salt producing centre. In 1768, the plan of the present street pattern began with the development of a market place and the erection of the old town hall. It is centred over an old pillar, probably a market cross, and was used for its original purpose until 1910. It was in this building that the South Shields Exchange Subscription Library operated between 1800 and 1856.

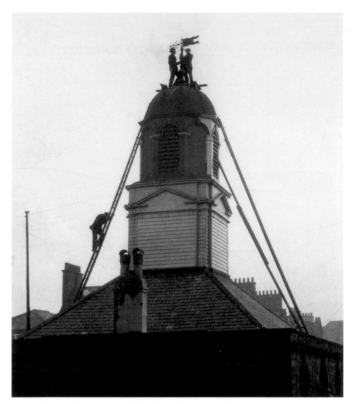

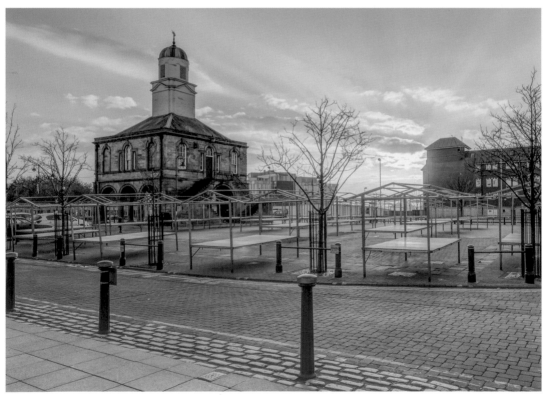

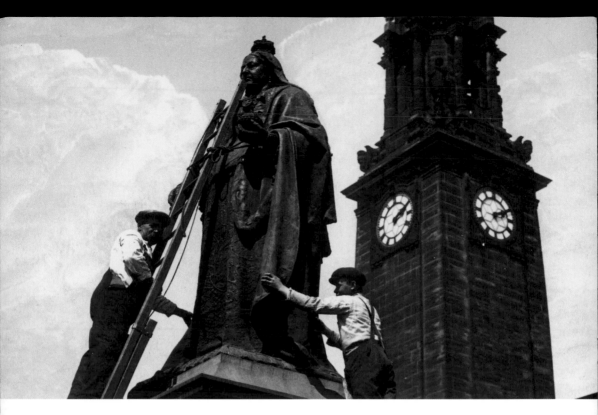

Town Hall

Queen Victoria would not have been amused at the indignity of being rubbed down by two council workmen, in full view of all and sundry! The image above looks to be from the 1920s. Famous for its hourly chime, the clock tower can be climbed by the brave and on Heritage Open Days there may be the offer of a guided tour. the town hall was bathed in blue light to mark World Diabetes Day in November 2012. It was one of almost 1,000 historic buildings and landmarks around the world that were illuminated in the colour blue, universally symbolising diabetes.

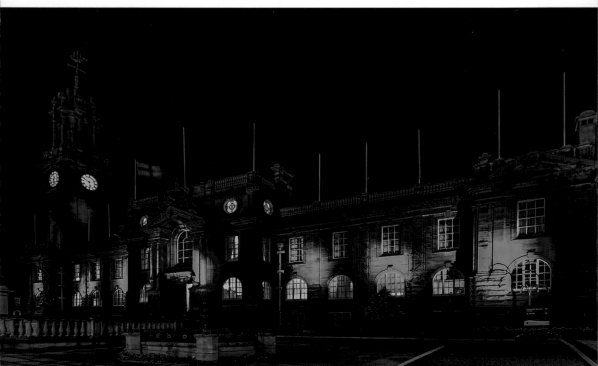

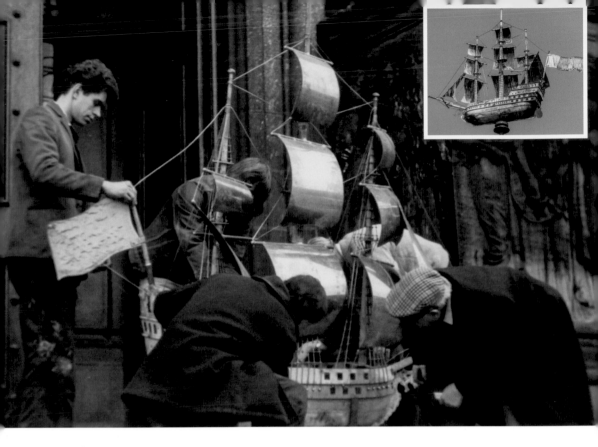

Weather Vane

The all-copper galleon that tops the town hall was given a complete overhaul in 1972. The ship was restored to her former glory and copper sails completed the restoration in the style of an Elizabethan galleon. Stories and urban myths abound about how many people could fit in the galleon but, as you can see, in full sail the ship is only the height of an average man! This image was taken at the top of the main steps of the town hall. Part of the dado frieze on the column supports, sculpted by J. G. Binney, can be seen to the rear of the capped gent. The winter of 2001 saw the galleon removed once again by crane; this time to allow restoration work on the stonework of the clock tower, which was partly funded by the National Lottery Heritage Fund.

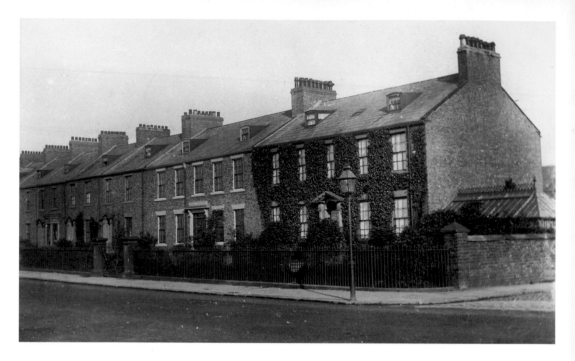

The Synagogue

Here you can see the top few houses in Ogle Terrace, now known as Beach Road. Some of the great and the good of the town lived in this terrace. At the end, ivy-clad No. 14 was completely demolished to make way for the building of a Jewish synagogue. The synagogue was completed and officially opened in 1933. The gardens at the front of the houses have been removed to make way for a footpath and green, tree-lined area.

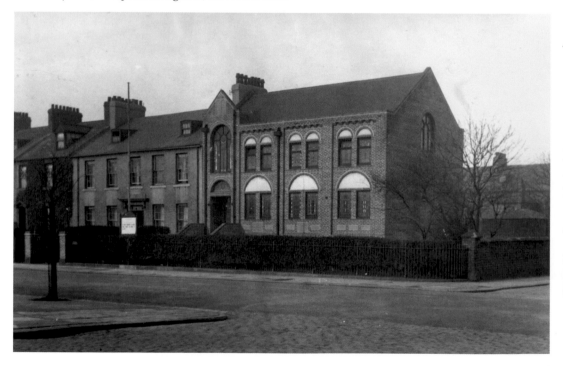

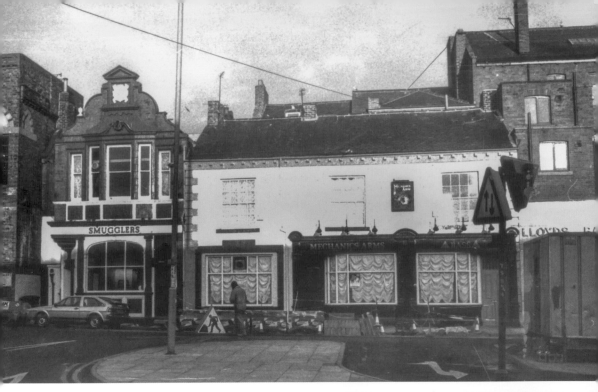

East Street Pubs

These two watering holes rub shoulders with each other in East Street in the town. On the right of the image above, the Mechanics Arms (colloquially known as the 'Mechs') has windows adorned with festoon blinds from the 1980s. A very narrow passage to the left of the Smuggler's leads, almost secretly, to King Street. Many people must walk past this entrance and never know it to be there. The pub has now reverted back to its original name, the Lambton Arms. Following his marriage to Eliza Pengelly in South Shields in 1870, Jack Liscombe became the landlord of a series of pubs in the town, among them the Borough Arms in Thames Street, the Stirling Castle on the Long Bank and the Mechanics Arms in East Street. Above the bar of the Mechanics there was a room known as the 'Free and Easy', where people could practice their entertainment acts. It was as a clog dancer that Jack really made his name, teaching one of the most renowned cloggers in the north, Jim Ellwood, who became the Pitman's Clog Dancing Champion of Northumberland and Durham.

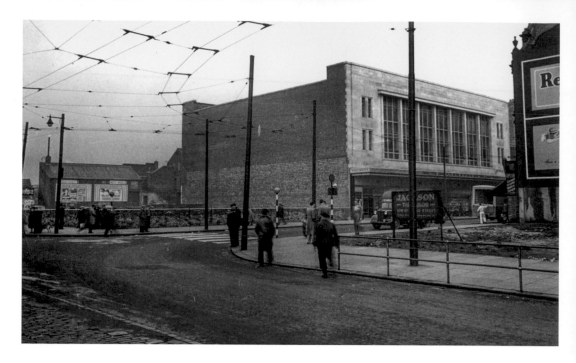

Marketplace

During the Second World War the marketplace was heavily bombed. In October 1941 a stack of bombs was dropped on the marketplace. Cans of burning oil and paint from Dunn's paint shop flew into the air, causing raging fires in many market premises. A leaking gas main caused Crofton's drapery store to burn and in a very short time Woolworth's too was on fire and eventually gutted. This black-and-white image from the early 1960s shows the new Woolworth's building. Today the premises are occupied by Store 21 and Poundland.

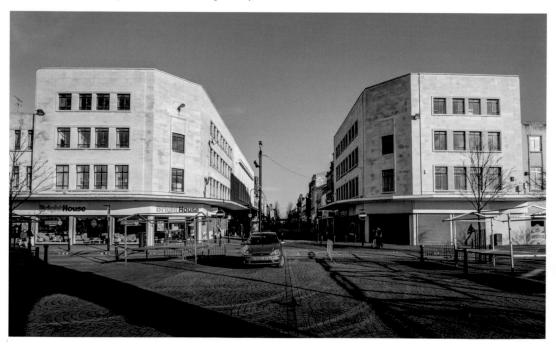

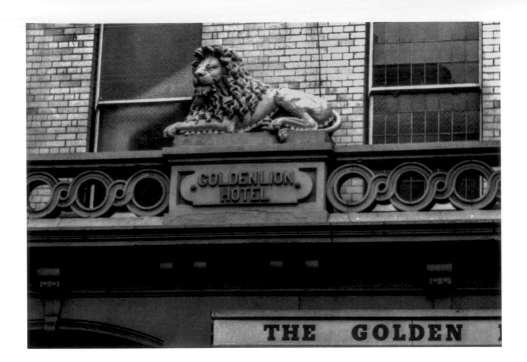

The Golden Lion

Originally part of the structure of the Golden Lion Hotel, erected around 1870, the lion now lives outside the impressive doors of the museum in Ocean Road. James 'Putty' Garbutt was commissioned to paint the Golden Lion Hotel with the owner requesting that the lion statue should be painted gold. The lion was indeed gold but with a green tongue! When asked why, Putty replied, 'Well, you cut me down on price and I had run out of gold leaf, so I thought I would give it a feed of grass instead!' The hotel was knocked down in 1973 and the lion was rescued. Most of the paint has long since worn off and he is now covered in green algae. This boldly carved lion, at rest with paws laid out in front, has been captured beautifully in this 2014 image.

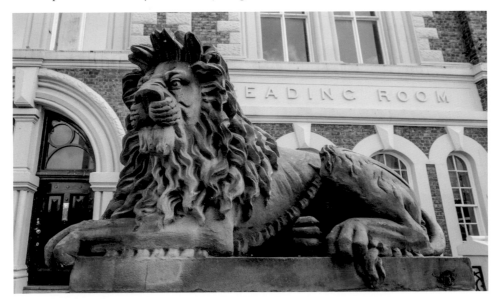

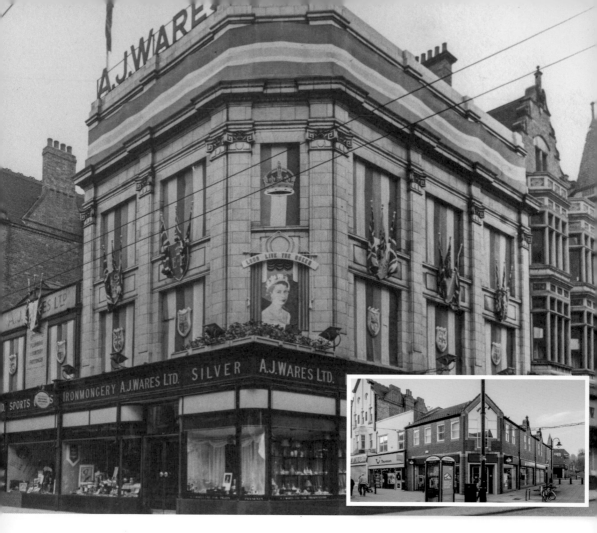

A. J. Wares

A. J. Wares' store can be seen here in King Street in 1953, bedecked in flags with a portrait of Elizabeth II to celebrate her Coronation. On one of the store's letterheads, the address reads Enterprise House, King Street, Salem Street and Queen Street. Truly, a large concern! Alexander (Sandy) Johnston Wares, a twenty-seven-year old Scot, born in Wick, set up the company in 1896. When he began trading, the firm specialized in ironmongery and supplied cooking ranges, lamps, cutlery and other furnishings. The store soon became known for its excellent products and customer care, while causing a sensation by being the first shop in South Shields to be lit by electricity. The range was extended to include bathroom fittings, gardening equipment, plumbing materials and gifts. Expansion continued into many more stores in the northeast until A. J. Wares had more than 100 staff. When Alexander died in 1949, the business passed to his sons, Alec and Hugh Wares. The building has long gone and Santander UK, one of the United Kingdom's leading personal finance companies, occupies that same corner today. Interestingly, some of the ornate masonry from the premises has been preserved and can still be seen on the roof of the new building.

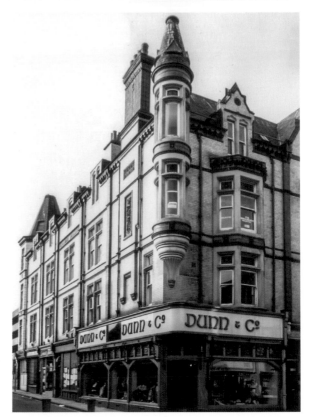

The Edinburgh Buildings

This image of the stunning Edinburgh Buildings was taken in 1983. Thomas Edward Davidson was the talented architect and he must have been so pleased with his work; his name appears in the brickwork. He lived in Salisbury Place and also spent some time living in Harton Village. Built over 100 years ago as a parade of shops with offices above, it has served many purposes. Dunn's, the hatters and gentlemen's outfitters, was the place to purchase your suit back in the day. Cellars complete with ovens later housed South Tyneside College's first cyber café. For several years the college had classrooms and an information centre in the building. At one time, South Shield's Photographic Society held their meetings in rooms above the premises. The impressive buildings still house small businesses today.

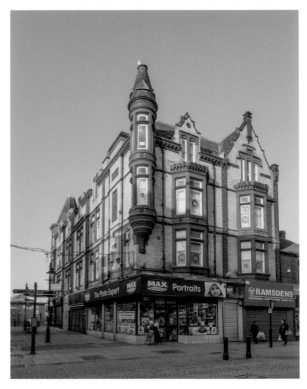

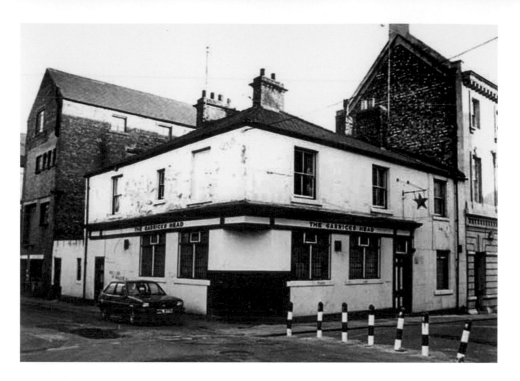

The Garrick's Head

The pub, on the corner of Salem Street and Queen Street, was closed to make way for an extension of the neighbouring Natwest Bank. No such extension materialised and the site became a small car park for staff of the bank. The Garrick's Head was named after the eighteenth-century actor David Garrick, supposedly due to its proximity to the old Theatre Royal in King Street.

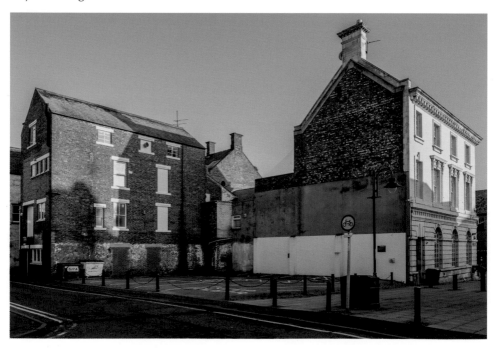

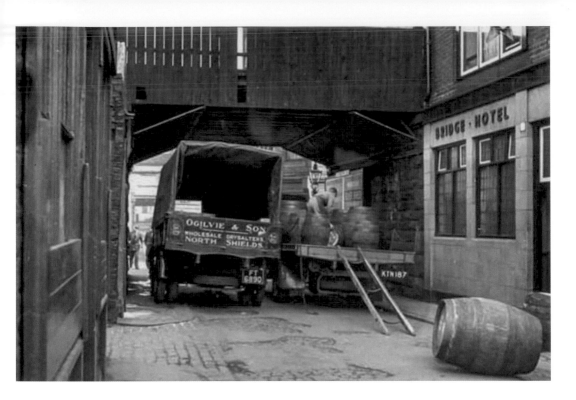

The Bridge Hotel

Here is Queen Street, which runs parallel to King Street. On the right you can see the back of the Bridge Hotel. Looking closely you can see where the lettering was fixed to the wall. Casks of ale are being delivered to the pub and Ogilvie & Son, wholesalers from North Shields, battle to get past the lorry.

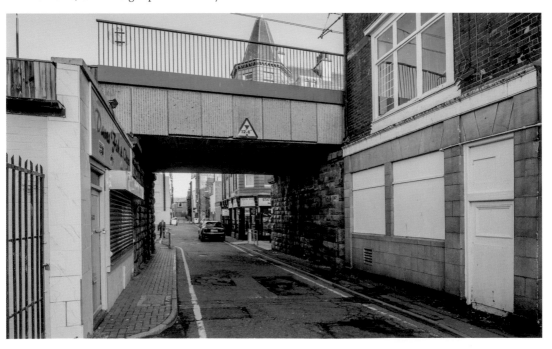

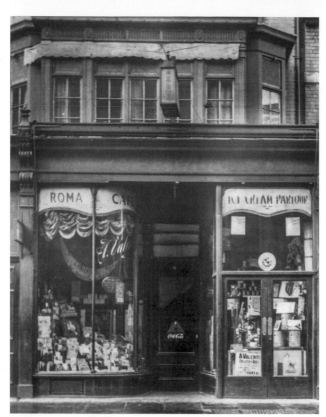

Roma Café

The Roma Café on Ocean Road was owned by Mrs Teresa D'Ambrosie and her mother, Angela Valenti. In the late nineteenth century, Guiseppe Valenti emigrated from San Michele, an area in Cassino, Italy. Together with his wife, Chrisanzella Nardone, and their children, he set up an ice cream business in Monkwearmouth. The image below shows Valenti's van CU-1253, CU standing for Caer Urfa, where the vehicle was registered (South Shields). Their business addresses included No. 5 Ocean Road, No. 3 Salem Street and No. 35 Ocean Road. The image was possibly taken in the early 1900s and today it is the famous Ice Cream Parlour of Minchella. The Minchella family has been serving fabulous ice cream in South Tyneside for over 100 years and it has become legendary.

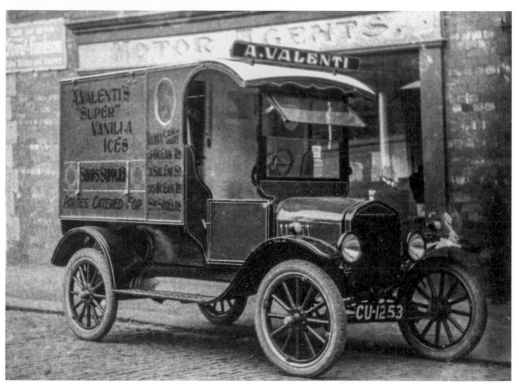

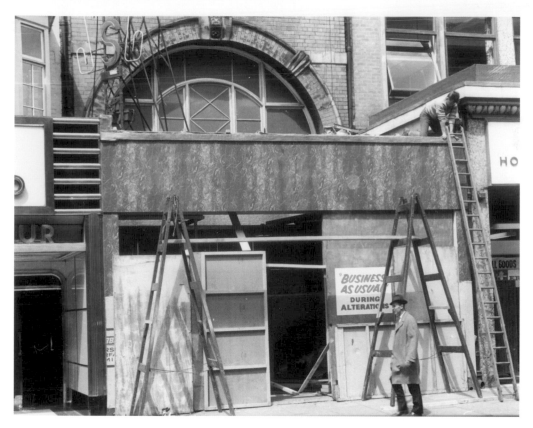

Royal Assembly Hall

The original entrance to the hall was the brick building with the round, arched window in Ocean Road. In 1938 the hall was converted into a cinema called the Scala. This image shows work in progress possibly putting a new shop front on. 'Business as usual' reads the sign, but I can't imagine many customers taking that advice! Today the premises are one of the town's many charity shops.

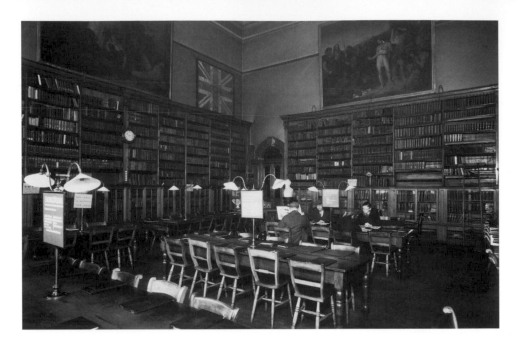

Library and Museum

In the first year of the library's opening (1873/74), nearly 3,000 people borrowed a total of 74,000 books. W. J. Haggerston, esquire, was the first librarian and the library was run on a staff of six! A visit to the library with its grand entrance, high ceilings and sweeping staircase made for a memorable event. In 1960 over 1 million books were borrowed and it was becoming clear that the building could no longer meet the demands of a modern working library. In 1976, chief librarian Rod Hill oversaw the library's move into a long-awaited new home in Catherine Street (now Prince Georg Square), just over 100 years after the library first opened its doors. In sharp contrast is the image of the reference library with its suite of computers.

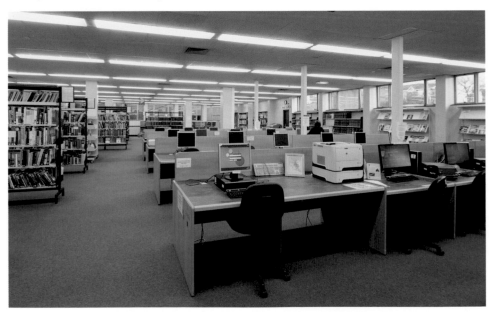

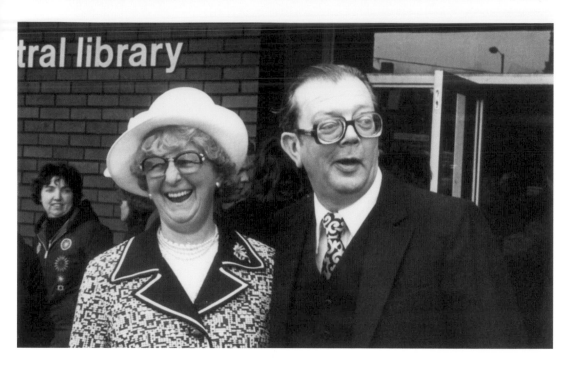

Central Library

Famous local author James Mitchell officially opened the new central library in April 1976. James penned the acclaimed series of local books *When the Boat Comes In*, which became a hugely successful series on the television screen in the 1970s. The series starred James Bolam as Jack Ford, a veteran of the First World War who returns to his impoverished town of (fictional) Gallowshield, in the northeast of England, in the 1920s and '30s. A fair few of the scenes were filmed in South Shields, including the cobbles of Mill Dam and the famous town hall steps. Here, the central library awaits its fate as a new state-of-the-art building is planned for the riverside.

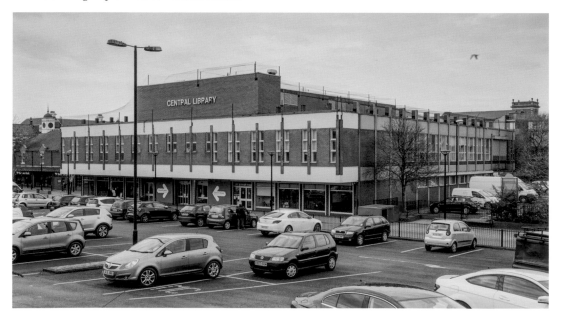

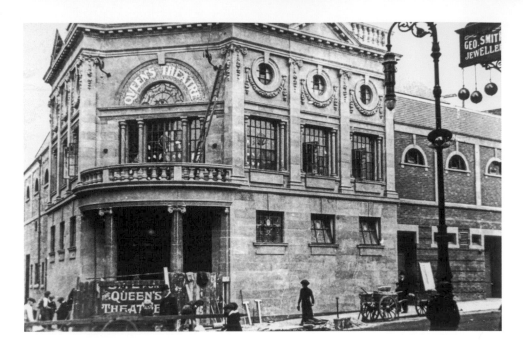

Queen's Theatre

Here is the splendid Queen's Theatre, which opened on August Bank Holiday in 1913. Messrs H. Gibson and P. J. Steinlet were the talented architects of the building and had over twenty theatres in their portfolio. The main façade was in brick and terracotta; the main entrance, on the corner nearest King Street, was in marble, with granite columns and mosaic tiles on the floors. The honour of being the first theatre to show the 'Talkies' went to the Grand Electric Theatre and the Queen's Theatre followed soon after. During a bombing raid in April 1941, the Queen's was set ablaze. Fortunately no one was killed; the site was cleared and lay derelict. The image below is of the same corner and shows the multi-storey car park in 1983. Various small shops lined Mile End Road underneath the hideous 1960s building. There was a nightclub on the ground floor in the 1960s, firstly known as the Ranch House Club and later Banwell's, which was the place to be seen! Jon Banwell loved to celebrate the club's birthdays. For their fifth birthday, stunt rider, Eddie Kidd, judged a competition to find the local lass that looked most stunning in her denims. A year later, topless model Linda Lusardi made an appearance!

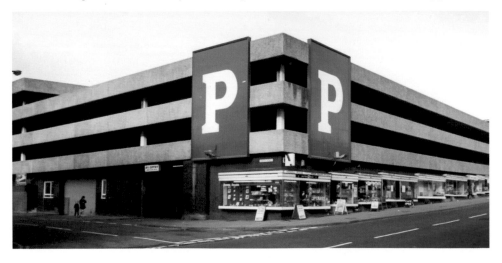

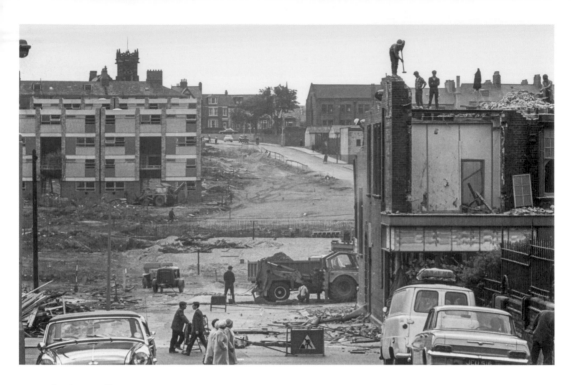

Anderson Street

Can you imagine this foolishness being allowed today? Some brave or misguided workmen are atop this building as they demolish it. This fabulous image shows the building of a new housing estate in the 1960s. Many terraced streets behind Ocean Road have been demolished in the name of progress: Dale Street, Agnes Street, Grace Street and Ivy Street to name a few. The tower of St John's Presbyterian church can be seen behind the new blocks of flats. Strangely hidden is the town hall clock tower.

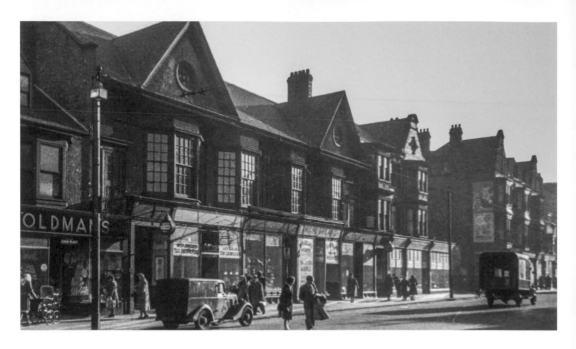

Crown Assembly Rooms

Ocean Road, showing the Crown Assembly Rooms at No. 76. Premises below included M. J. Collins' café and Miss Moore, a fancy goods dealer. Wicked nightclub is now housed upstairs and Noble's amusement arcade is on the ground floor. The buildings on the right were demolished to widen Anderson Street. Goldman's (confectioner) is to the left and other premises on that block include Dietz, the German pork butcher; H. Robson, the baker and the Grapes Hotel. As part of a huge regeneration project, this area has had much-needed flood defences installed and now looks stunning as a tree-lined boulevard.

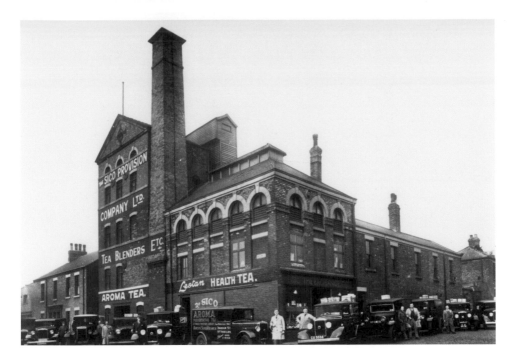

SICO

This is a lovely image of SICO provisions staff with their substantial fleet of vehicles, standing outside the ornate premises of Sidney Coston, who established the business in the 1890s. The building above stood at the corner of Ingham Street, off Mile End Road, and looks to be dated from the 1920s. The evocative image below shows ladies taking tea, each served by a waitress. Possibly posed for advertising purposes, note that the lady pouring tea has SICO on her bonnet, SICO being an abbreviation of *Si*-dney *Co*-ston.

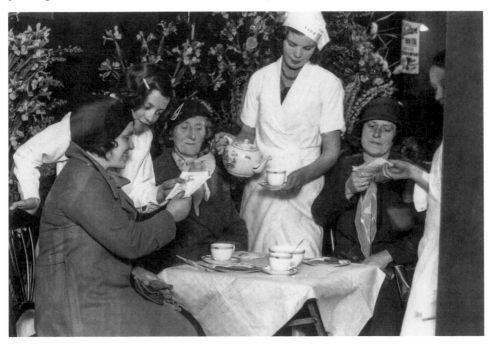

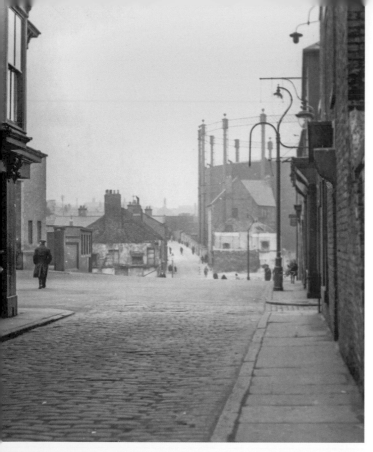

The Gasometer
Here is a 1930s image taken by Miss Amy Flagg, our well-known local historian. The gasometer dominates Waterloo Vale and is still a very distinct landmark. It was installed in Oyston Street in the early 1900s to store coal gas and town gas. Over the decades it had grown grimy and rusty, and for a time in 2009 it was shrouded in a protective coat while it was overhauled and repainted. This 2014 image looks down to the valley from the opposite direction.

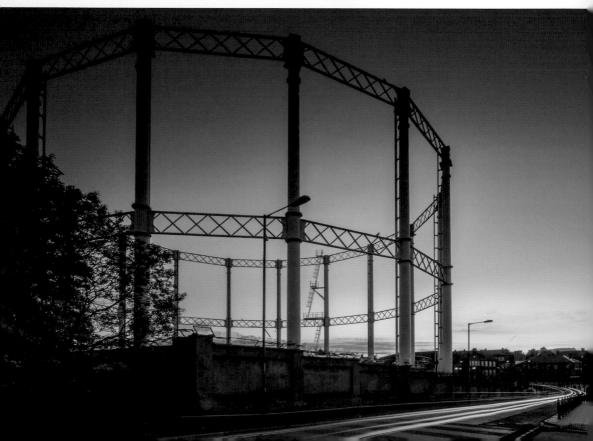

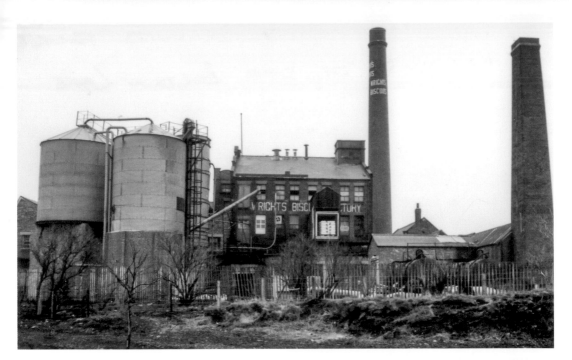

Wright's Biscuit Factory

Wright's biscuit factory was originally set up in Holborn, South Shields, in 1790 to supply ship's biscuits to the many sailing vessels in the Tyne. During the nineteenth century the number of sailing ships in the river declined in favour of steamships, and the demand for ship's biscuits fell. Wright's then changed their direction and started to produce fancy biscuits. Following a disastrous fire at the factory in 1898, substantial new premises were built in Rutland Street, Tyne Dock, as seen in the 1983 image above. During the Second World War, the factory remained open day and night, making biscuits for the Army. Some 300 employees, mainly women, worked shifts around the clock. Wright's had several claims to fame; among them, celebrated children's illustrator, Mabel Lucie Attwell, was the designer of their famous mascot – a curly haired boy called Mischief. Children could join the Mischief Club. Wright's closed in 1973 but reopened two years later under the name of F. C. Lowes – this time making dog biscuits. It finally closed its doors in 1983 and the buildings, including the famous chimney that dominated the Tyne Dock area, were demolished.

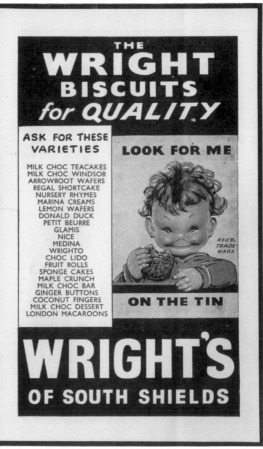

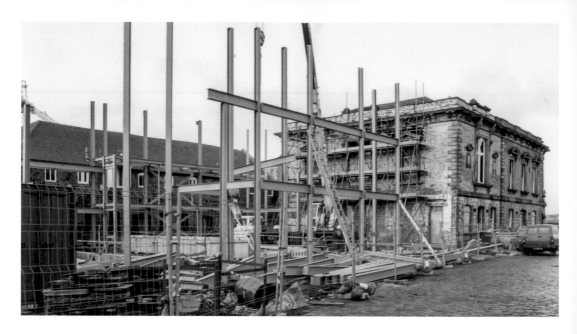

Customs House

Until 1848, Newcastle had the only customs house on the River Tyne and all shipping was directed upriver. After that date a separate customs house was established for Shields and Blyth, located at South Shields. When the Dalton's Lane outbuildings were refurbished in 2004, the builder found old mortuary slabs. With further research it was discovered that one of the buildings had previously been used as a morgue, and the stylish apartments in front of this building had been the river police station. Any bodies found in the river were taken directly to the morgue behind the station and autopsies were performed. Indeed, in the River Police Report of November 1891 it was stated that the number of dead human bodies was forty-four males and four females. Times and safety measures have changed for the better.

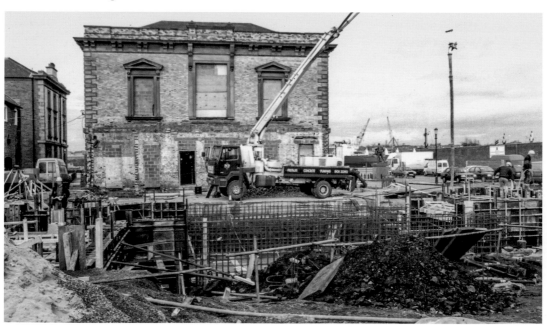

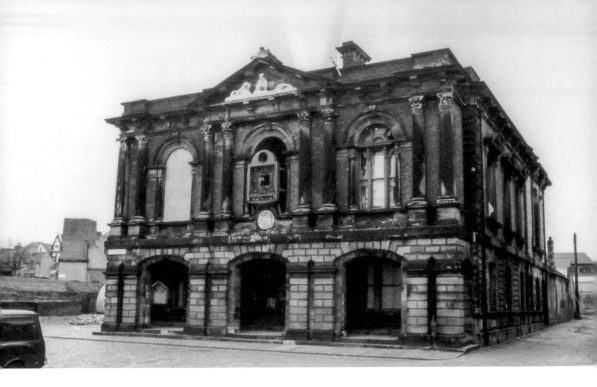

Customs House

South Tyneside Folk and Blues Club used to meet in local pubs. In August 1980, the group met in the Station Hotel to discuss bringing the customs house back to life and being host to their group. They met to elect a committee but another group was also working hard to ensure the scheme was a success. The Arts and Live Music Association (ALMA), envisaged a club presenting different kinds of live music every night of the week. ALMA hoped there would be interest from a brewery to input some cash, so it could be opened along social club lines.

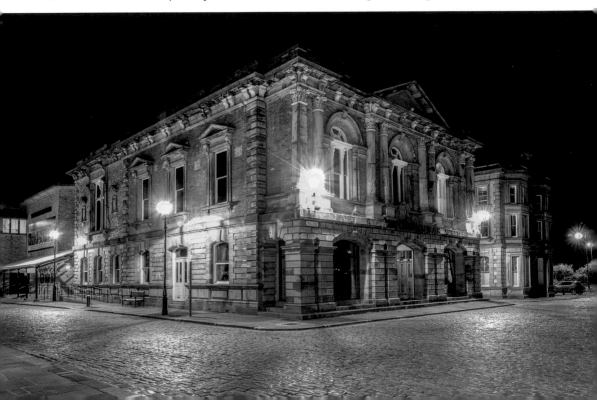

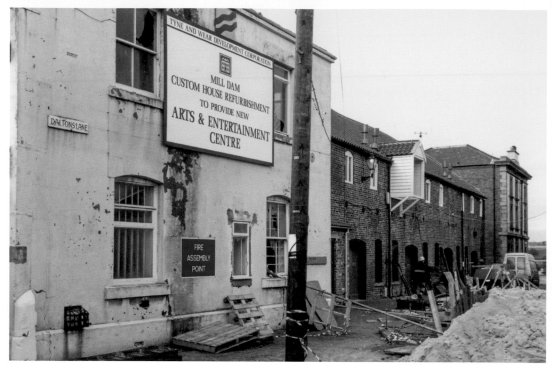

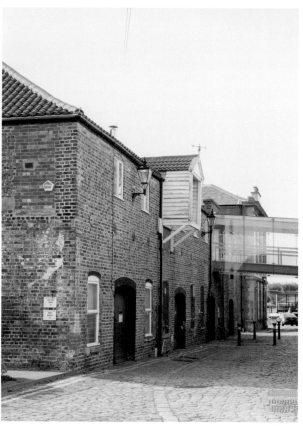

Customs House

The customs house has been transformed into a premier arts centre, offering great arts and entertainment for all. Whether you want to dine in the Green Room, catch the latest movie or see a play, the venue is a must visit. Local comedians Sarah Millican, Chris Ramsey and Jason Cook recently performed at the Customs House Gala to raise funds. The stars raised £25,000 after performing two shows in February 2015.

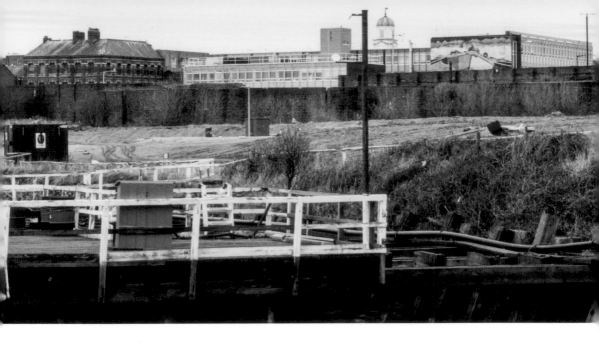

Harton Staithes

Here you can see derelict Harton Staithes, once teeming with coal trucks heaving coal into waiting colliers. A far cry from the tranquil Riverside Park we have today. A subject of much discussion, the BT Building is here to stay. Personally, I prefer the building seen from the river, as it reflects the Tyne in beautiful tones of blue and green. Construction was completed in September 2011. The £10.5 million Business Centre was designed by +3 Architecture and built for the council by Miller Construction. The building has been occupied on a long term lease by BT, the council's strategic partner, and they have created 500 new jobs.

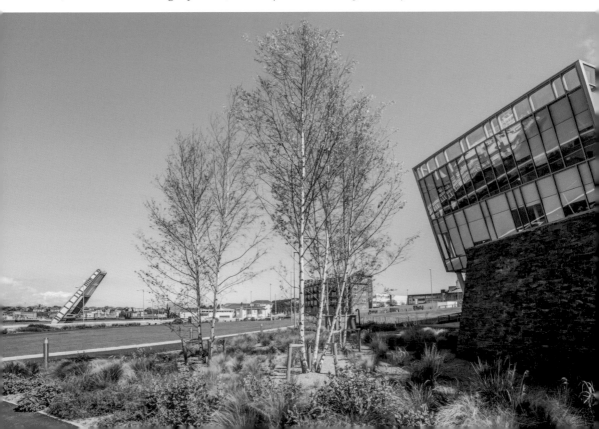

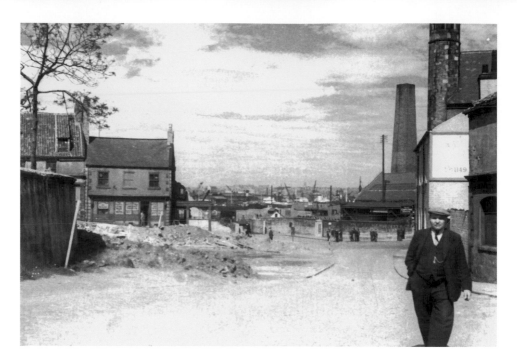

Mill Dam

While many of the old areas of Shields have disappeared almost completely without trace, at least one still retains some of its rich character. Much of what remains of the locality has now been given over to private housing but some businesses still survive. Here is a view of old Coronation Street in the 1930s. The remains of Cookson's Glassworks chimney can still be seen and Union House looks much cleaner, probably due to lack of industrial grime. The view of the river from these luxury apartments is stunning!

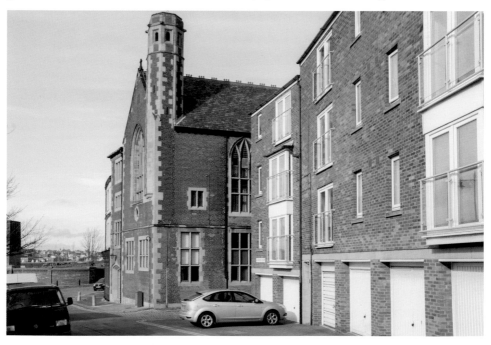

The Steamboat

These particularly attractive buildings are No. 27, the Steamboat pub and the adjacent building, No. 33 – formerly the post office but now absorbed by the pub. Four faces of mirth are sculpted on the frontage and some would claim them to be the best-preserved set of gargoyles on Tyneside! These strange hand-carved faces are said to have been carved when the building was built in the 1850s. The image below is from 2014 and the old postbox is still in use.

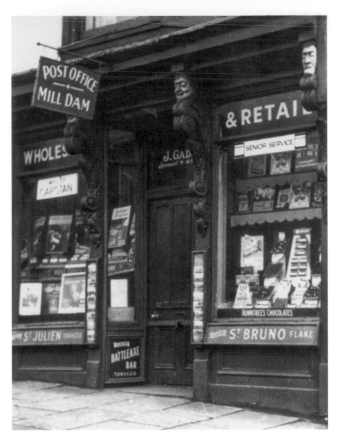

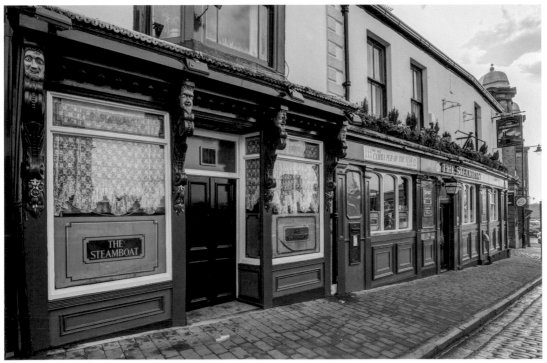

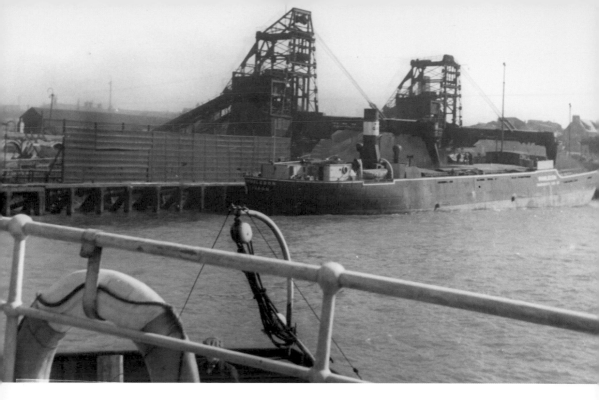

Harton Coal Staithes

The coal industry flourished in Victorian times, drawing immigrants from far and wide. In South Shields the population soared from approximately 12,000 in 1801 to 75,000 by the late 1860s. Over 100 years ago you could not stand here as it was a bustling coal jetty, but as industry on the river declined the land remained derelict. In early 2011, the council appointed internationally renowned landscape architects, Grant Associates, to design a new, green, breathing park on this site. Balfour Beatty began work in the summer of 2012 and the park was completed just over a year later.

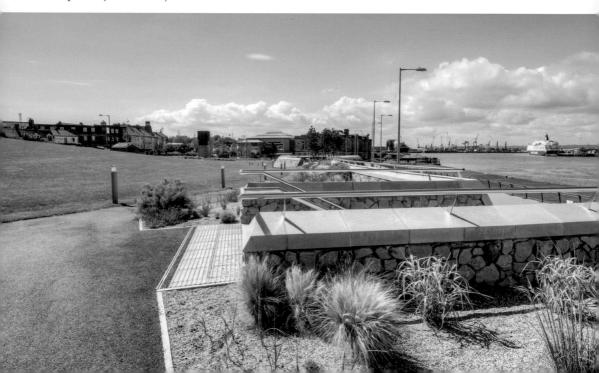

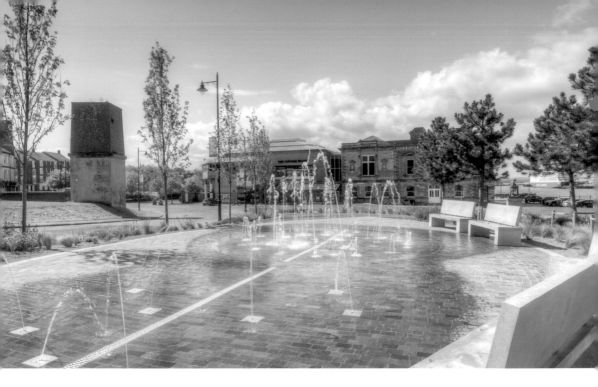

Riverside Park

The high-specification design of the park includes a curved, stone, ribbon wall; a promenade; a striking water feature; lawns and colourful planting, as well as garden seating areas and a dramatic pine grove. As part of the town centre's riverside regeneration, the park has, in some way, given the river back to the people of the town. The park was officially opened by TV presenter Julia Bradbury in November 2013.

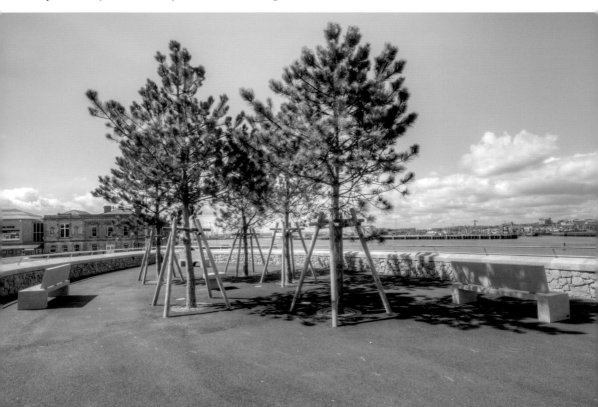

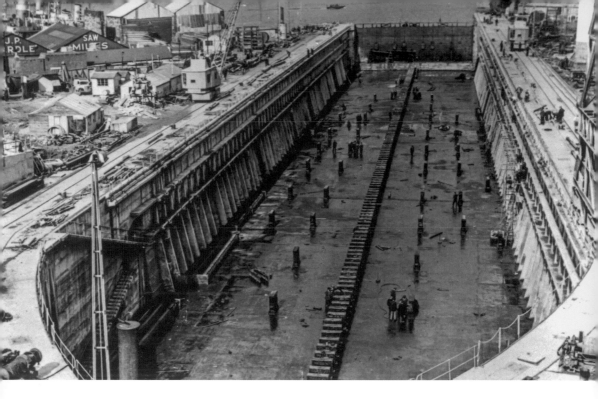

Market Dock

This black-and-white image shows the working Market Dock. It is a complete contrast to the image below. *Fleet*, by Irene Brown, is a collection of seven stainless steel, nineteenth-century collier brigs in full sail. They are set beautifully in the flooded former Market Dock, among the new housing development at Captain's Wharf. The brightly polished ships reflect patterns of moving sky and water, giving the impression of a fleet heading out to sea. They were installed in 2004.

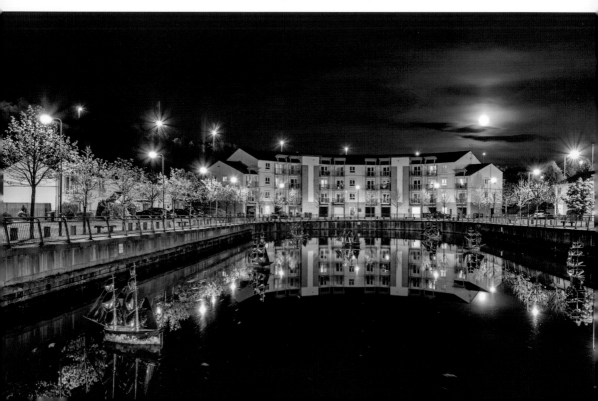

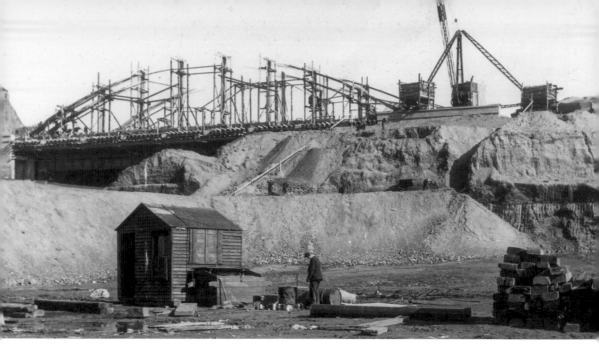

Heugh Bridge

The area of land behind the bridge was known as 'the Heugh', hence the name. In earlier times it was also known as Studley Bridge and I have heard tales of youngsters walking right over the top in their bare feet! In recent times it has been covered in anti-climb paint, which makes it difficult to get a good grip. The bridge was built in 1938 to carry the new road from the market, over the railway terminus, to new factories and the quayside at Wapping Street. It is more commonly known as River Drive Bridge and was officially opened by the Minister of Transport, Capt. Evan Wallace.

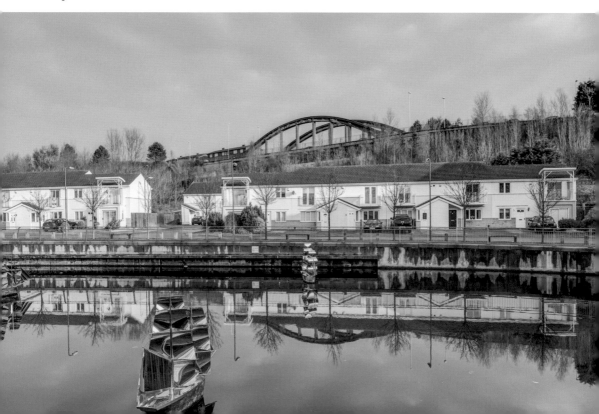

Readhead's Landing

A view up Corstophine Town with the entrance to Readhead's Landing to the left, on what was once River Street. In the distance the covered-in walkway connecting Readhead's administration buildings spans the road. The Port of Tyne's development plans required the closure of historic Readhead's Landing, which was the only remaining direct public access to the river in the town. The work was required to provide additional berthing for the handling of containers, bulk and conventional cargoes as part of a massive renewable energy expansion plan, which would create hundreds of jobs. A campaign group was formed to protect the restricted right of way from closure but the campaigners lost their fight and the historic landing saw its demise in 2013.

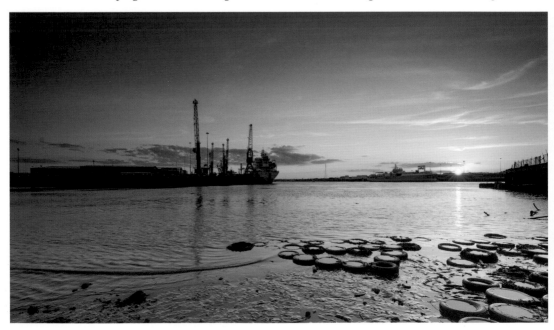

Kittiwakes

The high window ledges of Readhead's were perfect for nesting kittiwakes and preparation work on the landing was put on hold after a flock arrived for the nesting season. Locals say they have been returning to this site for a very long time. The RSPB got involved, saying 'We have spoken to the Port of Tyne, and it is our understanding that work has been stopped near the site where the kittiwakes are nesting, and will not resume until after the birds have finished nesting.' The famous bronze First World War memorial plaque, which James Readhead Esq. had erected on the outer wall of the building, now has a new home at the newly constructed Riverside Park beside the customs house.

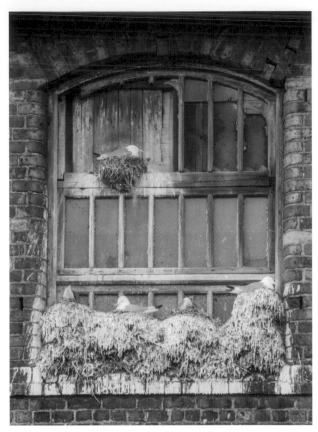

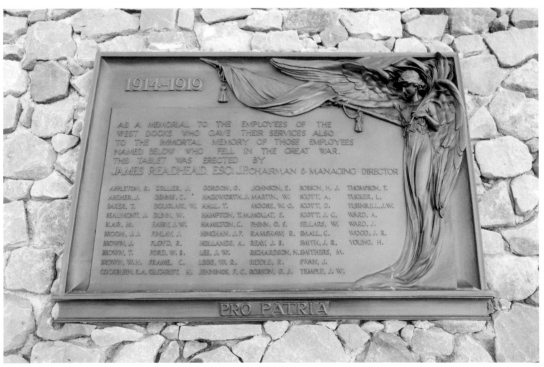

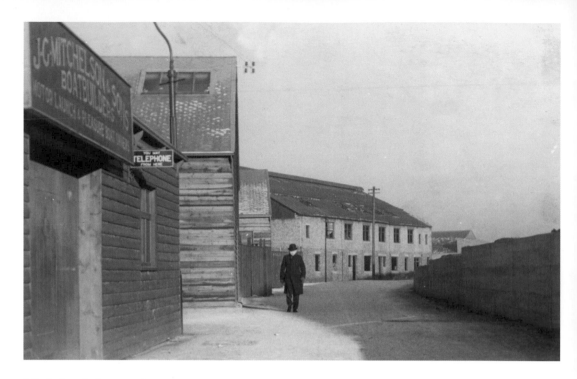

Mitchelson's Boatyard

Here is J. G. Mitchelson's, a well-known boatbuilding yard on Wapping Street in 1938. Jimmy Mitchelson had worked as a boy at the old Readhead and Softley's yard at the Lawe, serving his time as a blacksmith. He then completed his apprenticeship at the Tyne Plate Glassworks. Boatbuilding actually began as a hobby in his mother's tearooms at the Pier Head. He eventually developed the pleasure boat business and had a large interest in the steam yacht *Cynthia*, which ran pleasure trips off the Tyne. The premises are now occupied by the North East Maritime Trust.

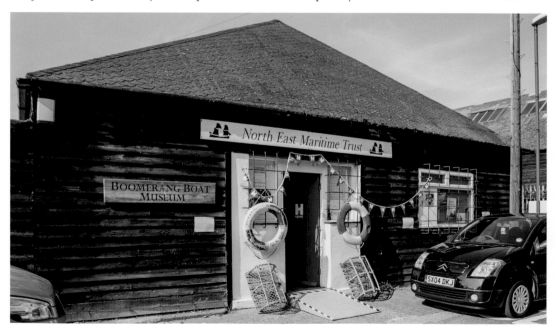

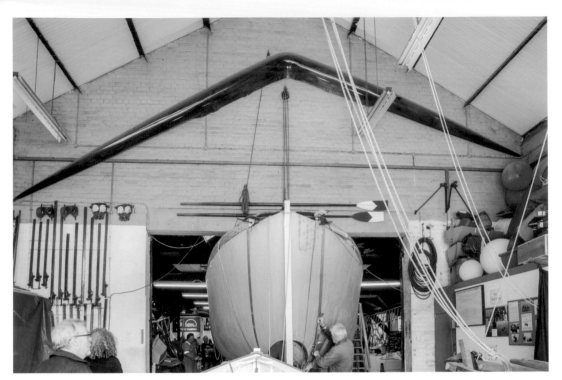

North East Maritime Trust

On Heritage Open Day in 2014, the trust opened its doors to the public. I was lucky enough to be shown around by Arthur Hamilton, one of the volunteers at the trust, seen in the image below. Shown here, the *Henry Frederick Swan* lifeboat is one of the current projects they are working on. The place is a hive of ongoing boat restoration and past projects have included restoring the famous *Tyne* lifeboat.

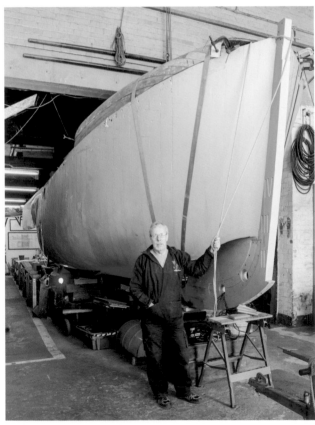

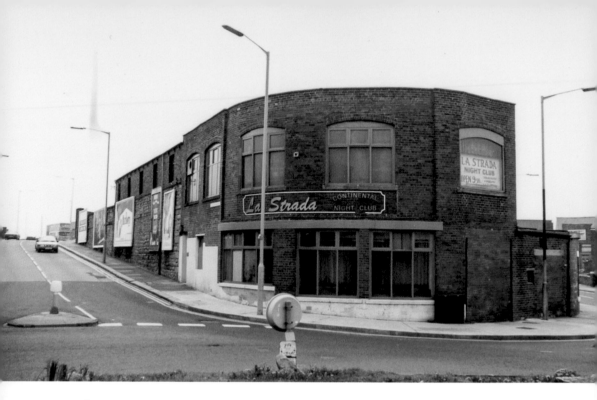

La Strada

When the La Strada nightclub opened in the town over fifty years ago, it marked a new era of glitz and glamour. The genius behind this new form of entertainment was twenty-five-year-old Sandford Goudie, whose father loaned him money to convert the old Smith's furniture shop into La Strada. For a time after its demise, Vaux Breweries ran the nightclub venue as Busters.

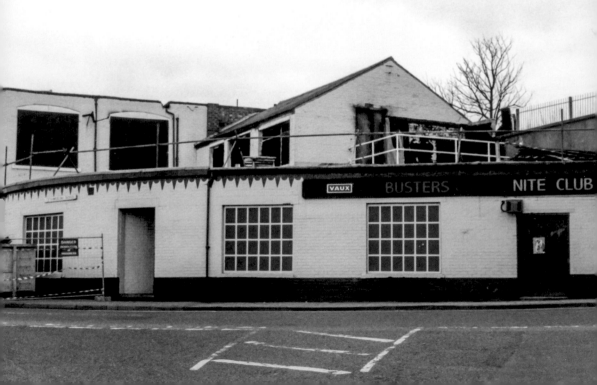

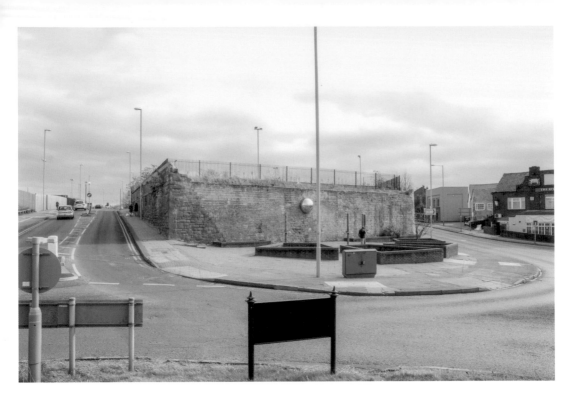

Nightclub Shadow and Memories
The small area now has a metal sculpture of high tables, bottles and glasses, mirroring its club past. *Nightclub Shadow and Memories* was sculpted by Jim Roberts.

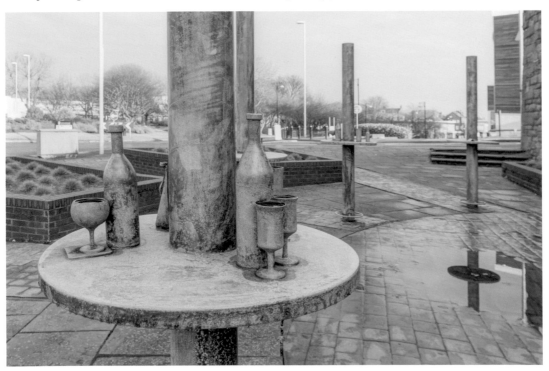

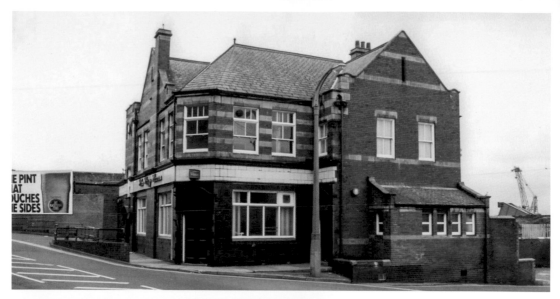

The Ferry Tavern

Another watering hole on the riverside was the Ferry Tavern, previously known as the Steam Ferry Tavern. It was built on the site of chemical works owner Isaac Cookson's old house. The Swinging Sixties saw this pub install the town's first fruit machine and in following years a juke box. In 2000 the Ferry Tavern and a quaint run of shops in Ferry Street were demolished as part of the Harton Staithes redevelopment programme. In 1873, a Northumbrian border collie was temporarily lost while his shepherd owner was driving his herd of sheep across the river from North to South Shields. The poor dog wandered around the place and frequently went to and fro on the ferry. He earned the name 'Wandering Willie', possibly after the poem of the same name by Robbie Burns. Ralph Cruickshanks worked on the steam ferries and took pity on him and took him in. Interestingly, or morbidly, the border collier can still be seen in a glass case in the bar of the Turk's Head Hotel in Tynemouth.

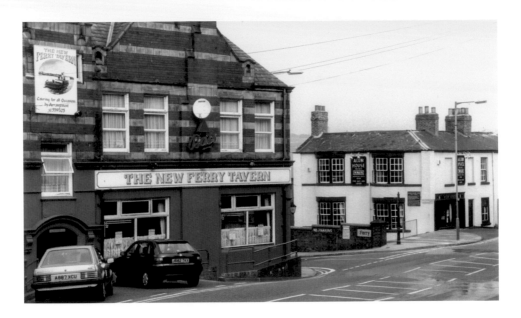

The Alum Ale House

Isaac Cookson's first chemical works were established here around 1760. Alum shale brought up from Whitby was unloaded on to the Alum House Ham and used in the production of glass. The word ham means 'hard', or river foreshore. This ham was used by scullermen and foyboatmen who plied their trades on the river. The Grade II listed building has a chequered past. A popular rendezvous for seamen, it had an unsavoury reputation. Arguably one of the oldest pubs in the town, it did have a spell as shipyard offices. While being converted into Davell Contract Furnishers, insignia was found on a wall above one of the fireplaces. At some point the Alum had been used by the Home Guard and the former managing director of the Tyne Dock Engineering Co. became their colonel. Today, with its contemporary decking and a fabulous view over the river, it regularly appears in CAMRA's *Good Beer Guide* – a real gem of a pub!

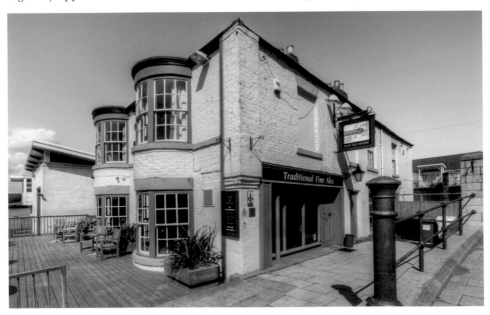

Dolly Peel

Dolly Peel is renowned in the town as a famous and colourful character. She was born Dorothy Appleby in 1782 on the riverside in Shadwell Street. Notorious as a fishwife, she was also a smuggler of brandy, lace, tobacco and scents. While researching this lady I have found newspaper articles where her husband has been referred to as Robert, Ralph and Cuthbert. Which one is correct? I think Cuthbert. When Cuthbert was caught by the press gang, Dolly sneaked aboard the ship too. When she was discovered after three days at sea, she served as a powder monkey, loading the guns on deck. Sadly Dolly died at her home in 1857 after a severe attack of bronchitis. A statue of her in River Drive depicts her in voluminous skirts, shawl round her head and shoulders, with her fishing basket or creel. Bill Gofton was the artist and the statue is made of Ciment fondu and cement. Ciment fondue-based mortars and concretes have setting times similar to Portland cement (Vicat set time around three hours). Dolly's memory lives on.

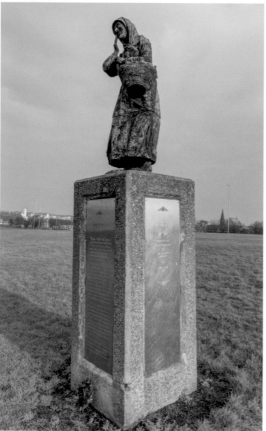

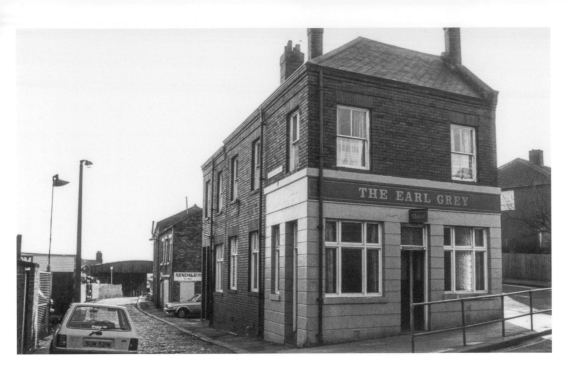

The Dolly Peel Pub

Here are two images of the same public house in Commercial Road. In 1983 it was known as The Earl Grey. It is now known locally as The Dolly Peel, after the renowned local fishwife and smuggler. A picture of Dolly adorns the entrance façade. Six cask marque accredited ales are on offer and are changed frequently – the pub has now entered the twenty-first century. Large TV screens showing sport, internet access and live music are all on offer.

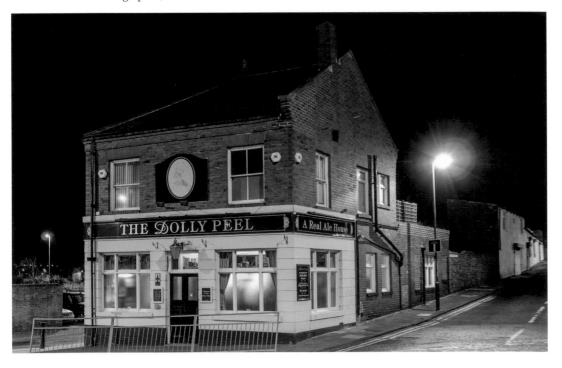

The Harbour

This image shows the jetty beside the Yacht Club. The bustling caravan park can be seen where we now have the Littlehaven Hotel. Families look set for the day. The image below shows a low tide and a very calm and picturesque harbour.

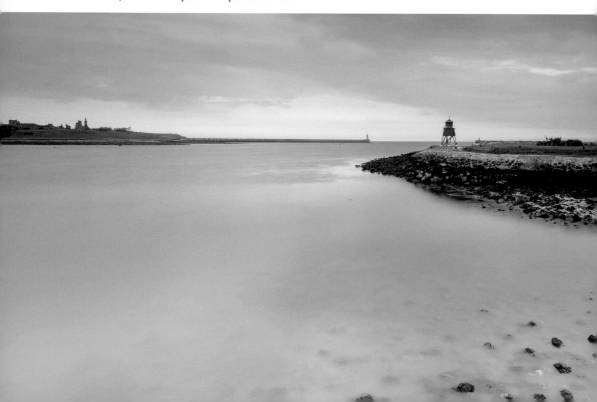

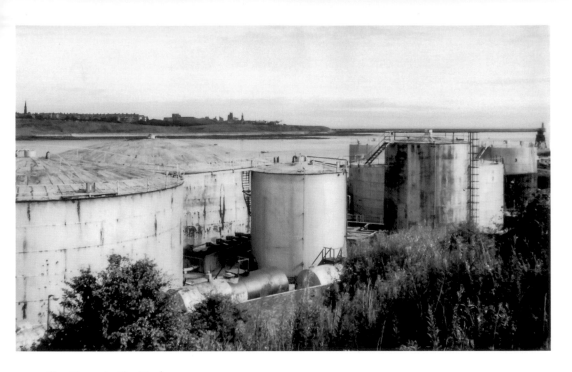

The Torso in the Tank

This 1980s image shows the giant storage tanks that made up the Velva Liquids complex on River Drive. Glamorous apartments and housing now occupy the site of the former tanks. Back in the summer of 1979, the gruesome 'Torso in the Tank' mystery unfolded. Poor local teenager Eileen McDougall was last seen at the Latino nightclub in January 1970. The gruesome discovery of her torso was made in 1979 when workmen were routinely cleaning out the tank. 'One of the finest pieces of police and forensic work resulted in the murderer receiving a unanimous, guilty verdict' – *Evening Chronicle*, 14 June 1980.

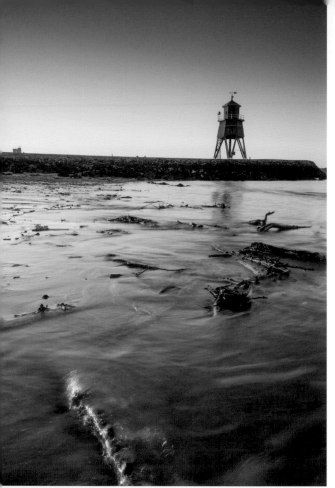

The Groyne

Where does the word groyne come from? Well, it seems to be of French origin and dates back to the sixteenth century. It means 'stone structure built from the riverbank to control land erosion', so it's fair to say the groyne is a pier and has its most prominent feature, the lighthouse, standing proudly upon it. The purpose of the groyne was to help the flow of the river and to protect the north beach from being swept away by the incoming, sometimes perilous, tides. The iron lighthouse was erected by Trinity Board House in 1882, after plans were made by the Tyne Improvement Commission. The lighthouse stands at 13m high and acts as a navigational aid, guiding ships in and out of the Tyne. It has a very unusual hexagonal shape and is held up on twelve iron legs, the central column being the most important. The groyne lighthouse was manned before the arrival of electricity. The inside is clad with oak, just like ships of the time and unusually, it has ship's bunks rather than beds inside. The iconic structure draws hundreds of photographers from far and wide to capture its splendour!

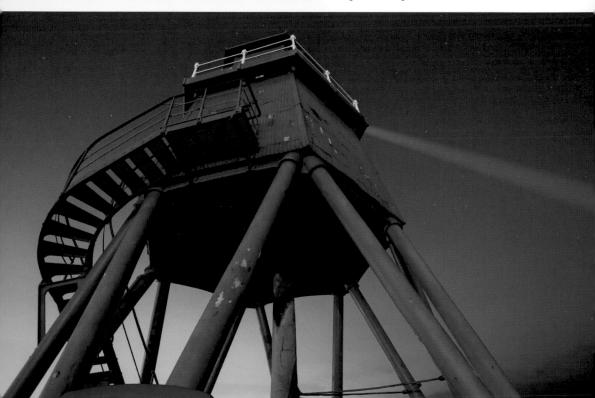

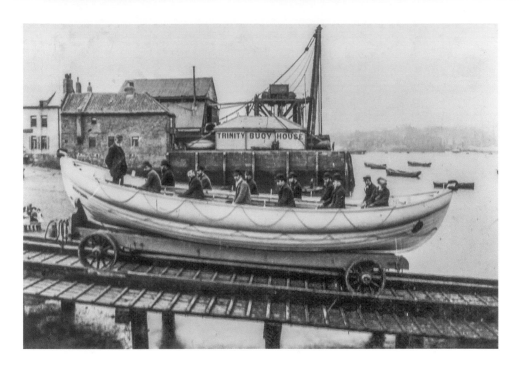

The *Bedford*

The pulling lifeboat *Bedford* was built by Lancelot Lambert at the Lawe and was launched from the Lawe Building Yard in December 1886. Miss Bedford, who lived in the south of England, bequeathed £1,000. This considerable amount of money, given to the Lifeboat Society Trustees, was for the lifeboat to be named after her brother, who was an engineer with the Tyne Improvement Commission. It is known that the *Bedford* was launched forty-five times on rescue operations, but it has not so far been possible to discover how many souls she saved during her service. There is a stark contrast with the image below of the lifeguards at their base at Sandhaven beach, photographed in the summer of 2014.

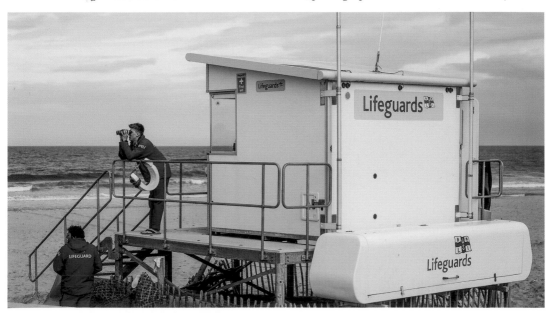

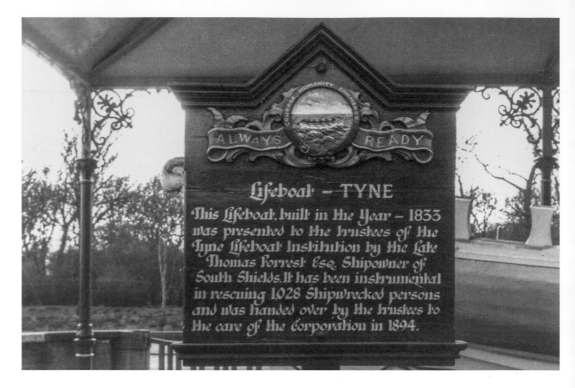

Tyne Lifeboat

This is a replica of the *Tyne* lifeboat that was built in 1833 and presented to the trustees of the Tyne Lifeboat Institution by the late Thomas Forrest, shipowner of South Shields. The original *Tyne* was instrumental in rescuing 1,028 shipwrecked people and was handed over by the trustees to the care of the corporation in 1894. The replica was recently given a makeover by the North East Maritime Trust and looks fabulous in her updated home.

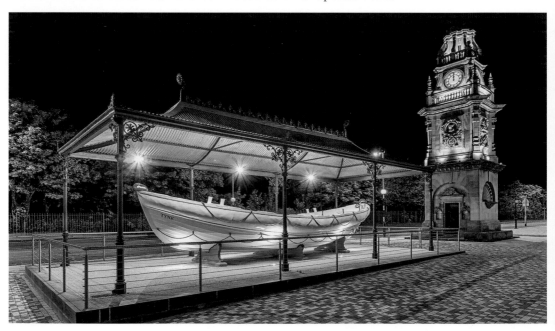

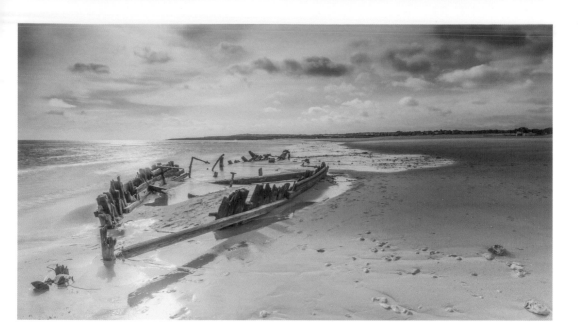

Constance Ellen

A piece of our maritime legacy is indeed the remains of the *Constance Ellen*. The shifting sands at Sandhaven uncovered the wreck in 2013. She came to grief in the great gale in November 1901, which raged off the east coast. The two-masted vessel was carrying a cargo of iron bars from her home port to Bowness, which was one of the reasons why she stuck fast instead of (like other vessels breached by the storm) being refloated. Thousands watched the drama unfold as the Volunteer Life Brigade took off the crew by breeches buoy. In more recent times, a fishing boat, the *Grenaa Star*, crashed into the pier and then started to take on water. The boat sustained severe hull damage and was beached in the harbour. A dramatic rescue ensued with the coastguard, the lifeboat crew and the pilot launch all playing their part in the unusual event. Local photographer Mick Ridley captured the drama at the scene.

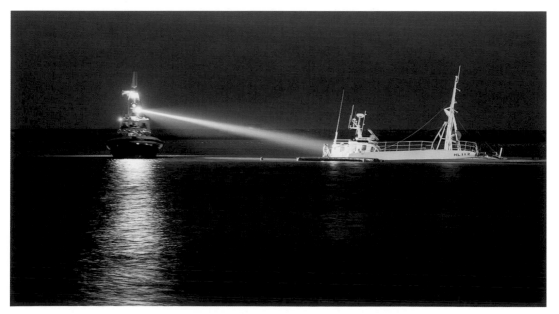

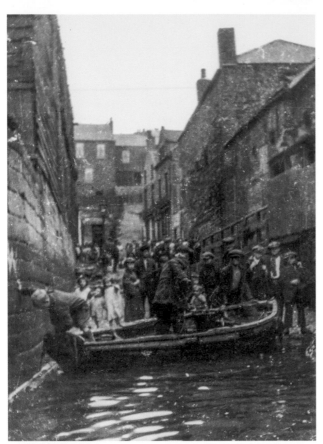

Riverside

There could not be more contrast between these two images, one taken in 1938 and the other in 2014. What would our ancestors have thought of our modern world? A crowd has gathered around this small boat, looking on curiously. Is it being launched or stuck or trying to land? This small boat landing was not far from the old ferry landing which has moved slightly. The modern image is a striking entrance to the town from the north side of our river. Our beautiful new Harton Staithes Park is a most welcome asset to the riverside.

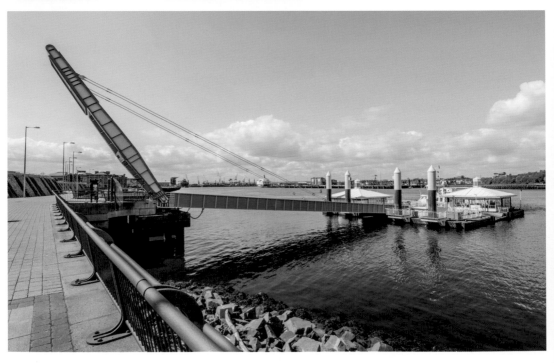

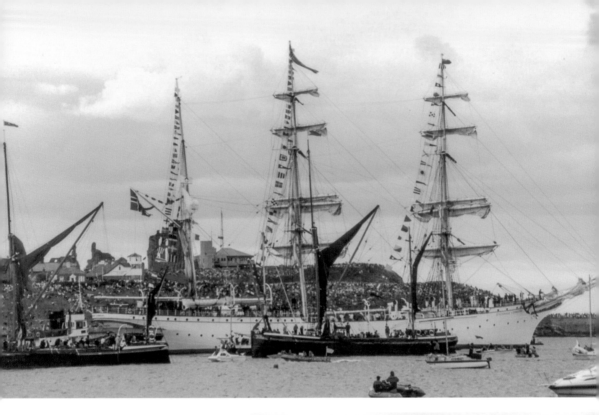

Tall Ships and King Neptune

When the Tall Ships Regatta last came to Tyneside in 2005, more than thirty-five vessels visited the area and attracted more than 175,000 visitors. The cost of hosting the event was £1.5 million, with an estimated £50 million being generated for the local economy. Shields' harbour had not looked so busy for generations. Former merchant seaman, Bill Lodge, was well known in the town for his early recycling projects. Seen here as King Neptune, he raised hundreds of pounds for the RNLI, the Flying Angel and the South Tyneside Merchant Navy Appeal. He never minded being called an eccentric – indeed his wife nominated him in a competition in the 1980s. Probably better known as the commissionaire at the town hall, he also created replicas of the Crown Jewels, including an orb made from an everyday orange ballcock.

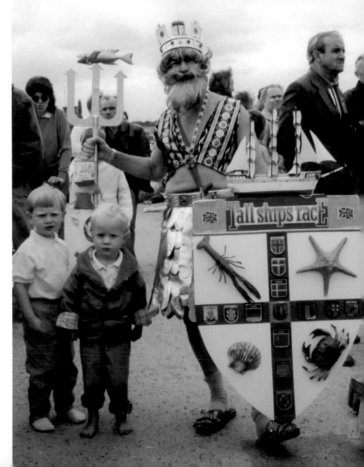

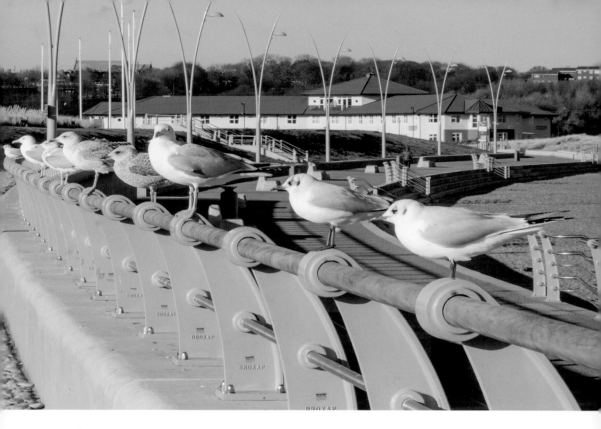

Seagulls

Seagulls are very much a part of coastal living. Love them or hate them they are here to stay, and I for one am quite partial. I realise that others may feel very differently, especially if you have had your sandwich taken out of your hand in King Street or one has alleviated itself on your jacket! *Larus Argentatus*, or herring gulls, are large, noisy gulls found throughout the year around our coasts, fields, reservoirs and lakes, especially during winter. Adults have light-grey backs, a white underbelly and black wing tips. Their legs are pink with webbed feet, and they have slightly hooked bills marked with a red spot. Young birds are mottled brown. These birds are enjoying the newly installed, hi-spec perch.

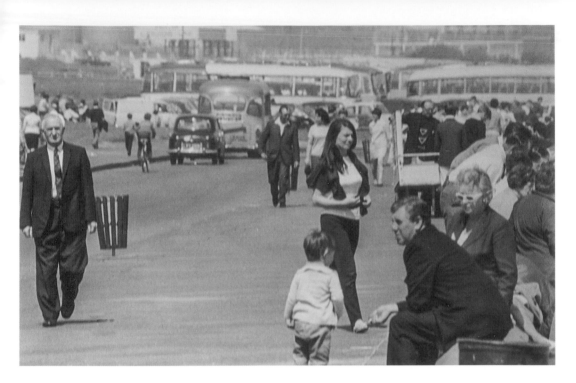

Promenade

A busy scene on the north promenade with the Velva Liquids complex in the background. Coachloads of daytrippers would flock to our award-winning sands in the '50s and '60s. There is even a newspaper and magazine vendor, John Ramsay, with his news stand, such must have been the demand for reading material for a day on the beach! Our innovative £5 million Littlehaven Promenade and Seawall project (*seen below*) was named as the 'Best Infrastructure Project' at the Royal Institute of Chartered Surveyors' (RICS) North East Renaissance Awards 2014. And rightly so!

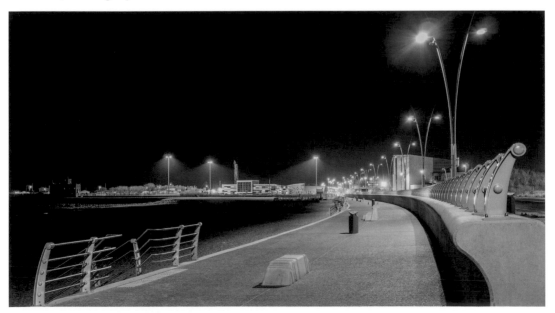

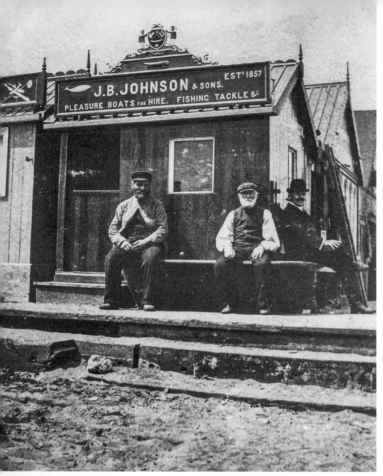

Promenade

These three gents could not have imagined how times would change for their descendants. The pleasure boats are long gone; it would be lovely to see them return. The pleasure boat huts that used to face the pier look so quaint compared to our vastly improved sea defence and tastefully planted promenade. If you are an early riser, like photographer Alec Jones, you too can enjoy a spectacular sunrise.

Pier Head

The Pier works yard has long gone but the historic Life Brigade House remains. The artwork *Sail* was delivered by Stephen Broadbent. It takes its inspiration from coble boats, which were used historically by pilots on the River Tyne. It consists of a concrete mast and a sail of ribbed metalwork. A circular cutout means visitors can look at views across the river.

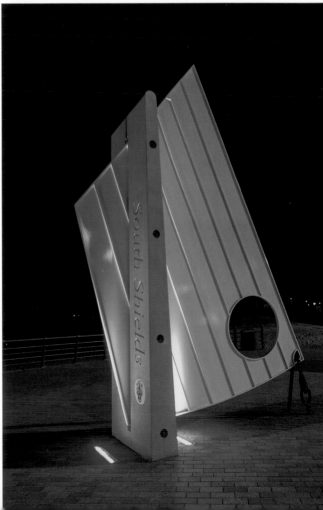

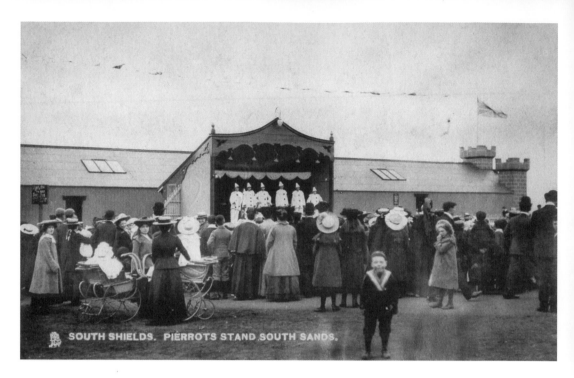

SOUTH SHIELDS. PIERROTS STAND SOUTH SANDS.

Seaside Fun

These two postcards show the good old days at the seaside. Raphael Tuck's & Son were art publishers to the King and Queen. This card of theirs depicts a popular pierrot show, and who could resist a donkey ride across the beach? The coloured postcard (*below*) was posted to an address in Gateshead in 1928. It simply reads, 'Coming home on Friday, love June'.

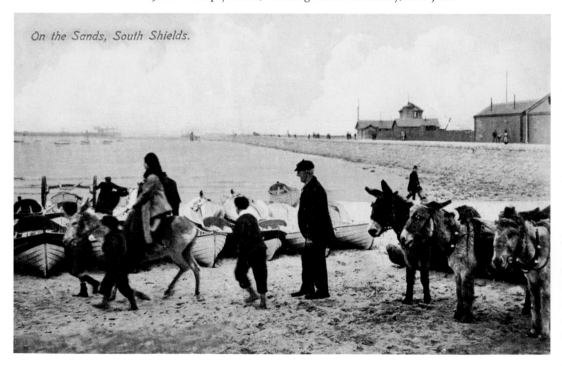

On the Sands, South Shields.

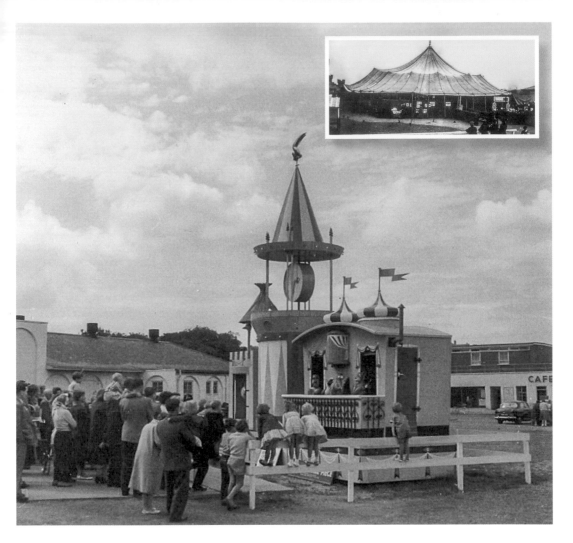

Entertainment

The 'Cosy Corner' was a huge marquee on the seafront. Many acts performed there during the summer months, including Burton's Bohemians, a talented troupe of pierrots. I am told the Guinness Clock (*main picture*) visited South Shields in the 1950s. The crazy clock toured around coastal holiday resorts including Paignton, Barry Island, Leamington Spa, Brighton and Great Yarmouth. A crowd awaits the show that entertained not far from the Pier Pavilion. Standing 25 feet high, the clock's internal mechanism was highly elaborate and included nine reversible electric motors and three synchronous clocks. It was the brainchild of Guinness advertising manager, Martin Pick, who previously had a background in engineering. Every fifteen minutes the crowds were spellbound by the four-and-a-half-minute routine, featuring well-known characters from Guinness adverts that everybody knew at the time. The menagerie included a sea lion balancing a pint of Guinness on his snout; an ostrich that had just swallowed a pint of Guinness whole; a pelican; a bear; a lion; a tortoise; a kangaroo; a crocodile and even an upside down kinkajou! The most famous of all, however, was the Guinness toucan that retained the public's affection from his debut in 1935 right up to his retirement in 1982.

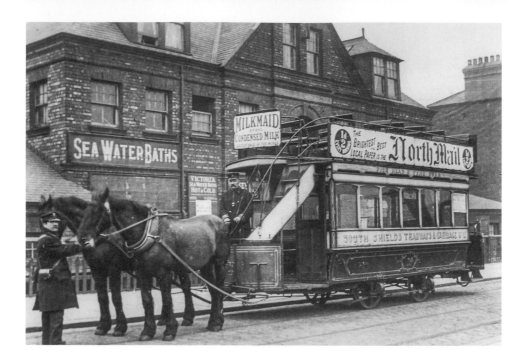

Sea Water Baths and Haven Point

This Edwardian image shows a tram drawn by two horses at the Pier Head. The driver and conductor can both be seen. The Sea Water Baths, also known as the Victoria Baths, sit behind; they were most popular in the early 1900s. Bathing in seawater and natural salt solutions has a long history. Almost 500 years before the birth of Christ, Hippocrates, known as the father of medicine, noticed fishermen who had injured their hands soaking them in seawater. They seemed to have few infections or complications from their injuries after the salt soaks, so Hippocrates encouraged his patients to bathe in warmed seawater. Our new Haven Point is practically on the same site and looks stunning in this evening shot.

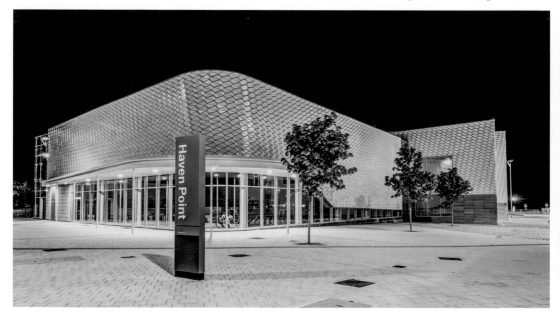

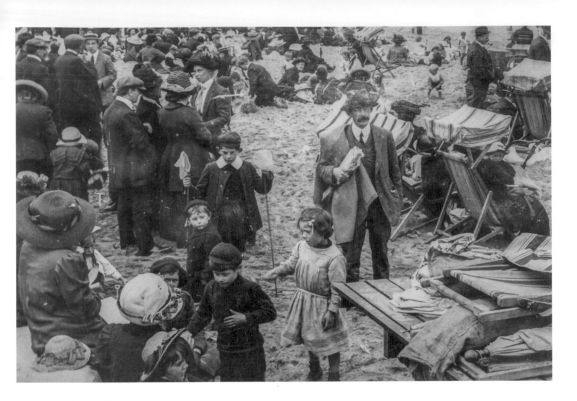

North Beach

Our new promenade area was once known simply as the North Beach. Here it is very crowded with folk of all ages. The men have suits and ties on and there are lots of folk 'plodging'. It will be lovely to see the beaches and promenade busy once again. With eye-catching artwork like the *Eye* and *Sail* by sculptor Stephen Broadbent, it is easy to see this happening. Illuminated at night, it becomes a colourful focal point of the promenade.

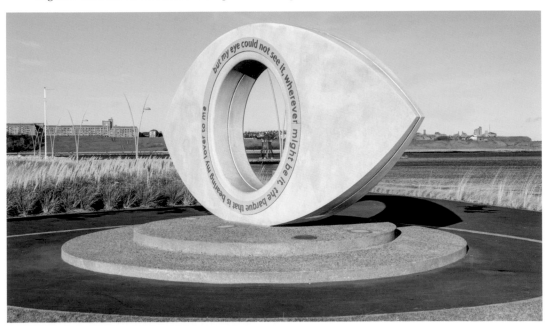

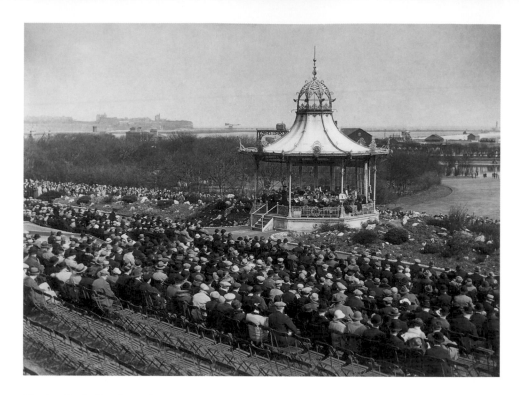

Marine Park Bandstand

Look at the crowds of spectators enjoying Proms in the Park. An enjoyable Sunday afternoon could be spent listening to the famous St Hilda's Colliery Band. In fact, all of the collieries had their own band. Also worthy of note are the People's Mission Silver Band from the Lawe, the South Shields Borough Police Band and even the Tramway Band. Below, the bandstand looks stunning in this photograph of the park at sunrise.

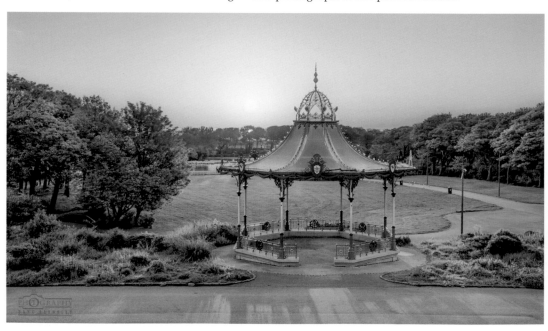

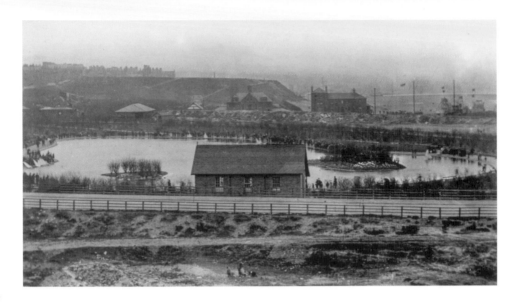

Marine Park

What entertainment could be had standing around the lake. Men and boys alike could wait and watch yachts sail by or catch tiddlers with their nets. The image below makes a fabulous contrast! Currently the only public steam-working, 9½ inch gauge railway in the UK, Lakeshore Railroad was first opened in 1972 and is still going strong to this day. Running for just under a third of a mile round the boating lake, the tracks meander through the many trees and over the level crossings before arriving back at the station. Children and adults alike can 'let the train take the strain' and view our much-loved park. 'Catherine Cookson Country' may be long gone as a brand, but memories live on and the carriages that follow the engine are named after Dame Catherine Cookson's bestselling novels, *The Whip, Menagerie, The Nice Bloke, The Blind Miller* and *The Moth* to name but a few. I wonder how many passengers make the connection while steaming around the lake with its resident swans.

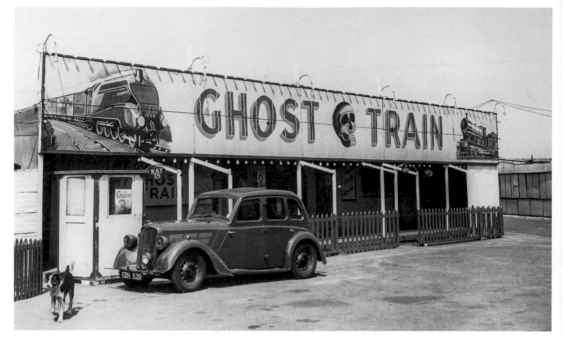

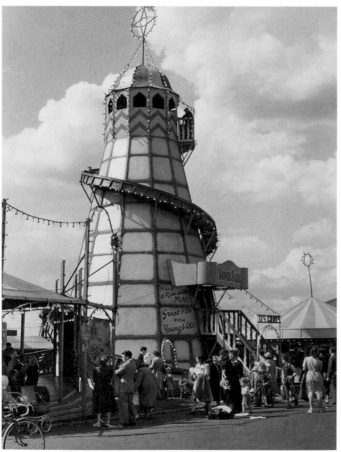

The Fairground
South Shields has always been loved for its seaside attractions, including the fairground. These images show the spooky ghost train and the ever popular helter-skelter long before arcade games and air hockey became the norm.

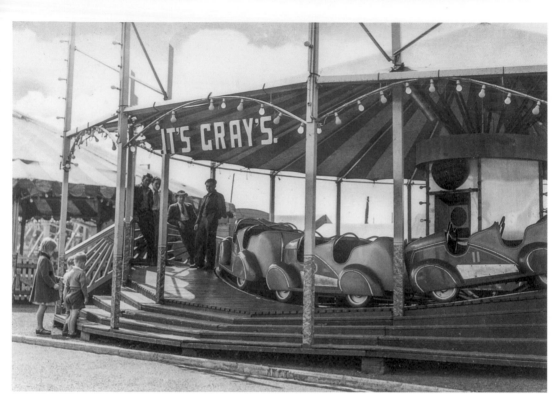

The Fairground

Gray's attraction can be seen here: 'Scream if you want to go faster!' How basic the mini golf looks compared to our very popular Pirate's Cove crazy golf. This was one of several publicity images for the amusement park, taken in 1969.

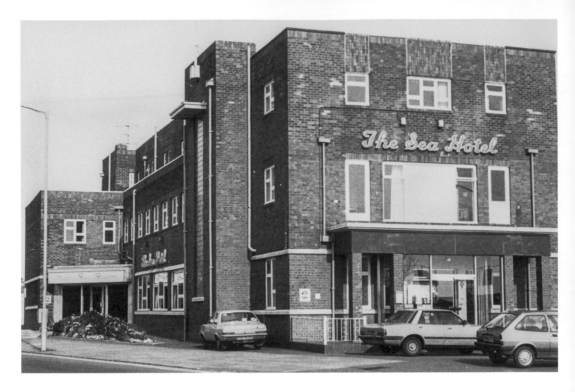

The Sea Hotel

The Sea Hotel sits in a really good location for visitors to the town. The building was completed in 1939 and has earned a splendid reputation with visitors. It now has a glass-fronted façade and has added 'Sea Lodge' to its hotel rooms. An extension to the side houses, the Fregate Restaurant is always popular and makes a perfect wedding venue.

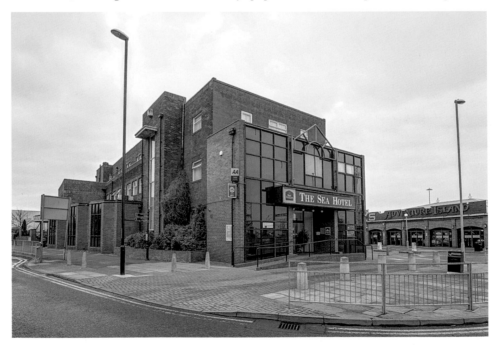

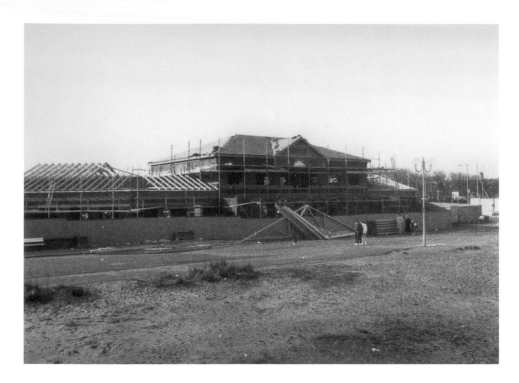

The Sundial

Here is a rear view of The Sundial public house and restaurant, under construction. The new image was taken after the redevelopment of the south promenade in 2010. The £2 million scheme includes sturdy decking and boardwalks, new lighting and unusual extra seating and artwork by Alison Unsworth and Melanie Jackson. A pleasant jaunt can be had at the weekend, along the front with a pint at the end.

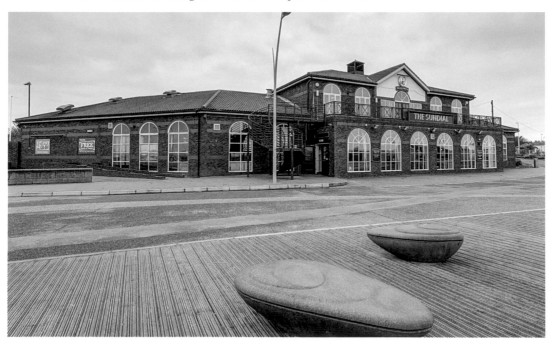

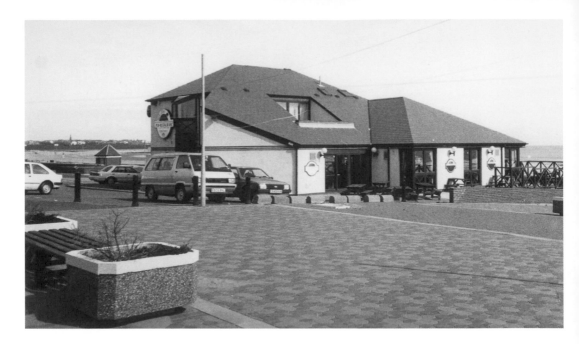

Sand Dancer

This unique coastal pub started life as Horizons. It then became the Corner House in the summer of 1994. Opened by Cookson Country Inns, it was the last design and development of local businessman, Mr John Thomas. At the time it was rumoured to be the closest pub to a main road and a beach in the whole country! Whitbread Breweries bought the concern just a year later and plans were drawn up to transform it into a Brewer's Fayre, family restaurant. The brewery organised a competition through a local newspaper, the *Shields Gazette*, to come up with an original, local name for the pub. Hundreds of entries flooded in and the company chose Sand Dancer for its reference to the natives of South Shields and its position on the South Foreshore.

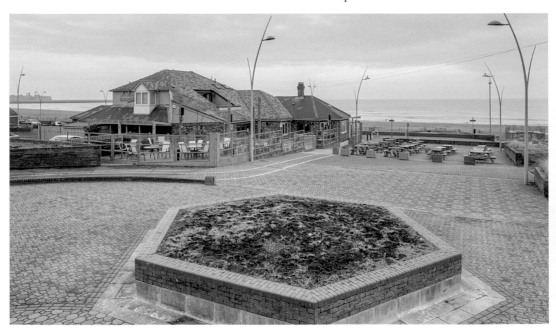

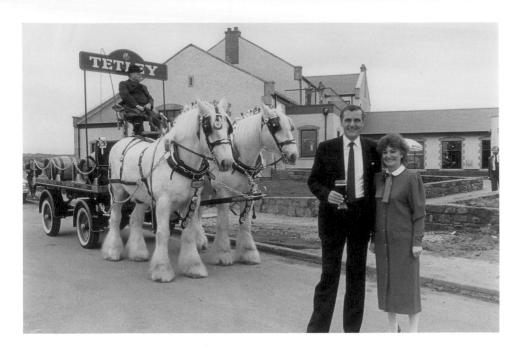

The Water's Edge

This great image shows Hebburn-born business woman, Mrs Doreen McRae, looking very pleased at the opening of her dream pub and restaurant in 1985. The dray and horses were supplied by Tetley's brewery and area sales executive Eric Dargon celebrated with a pint. During a visit to this scenic corner of the beach near the Trow, she felt there was a definite need for something special for the crowds at Sandhaven. An investment of £500,000 and the pub-restaurant complex was born. The Wacky Races came to South Shields in November 1986. A competition to have the first bottle of Beaujolais Nouveau in South Shields was won by the Water's Edge! By 10.15 a.m., a bottle had been sped in a taxi from wine merchants in Newcastle and brought in a speedboat from South Shields pier, piloted by head chef Peter Burden. At the restaurant it was welcomed by Raymond Court-Hampton. Looking every inch like James Bond, he waded into the North Sea to uncork the classic red. It is such a shame that today it looks forlorn, drab and unloved.

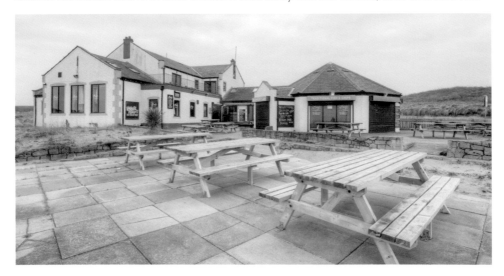

Trow Rock Disappearing Gun

The Victorian artillery piece that sits on the headland at the south end of the beach at South Shields is known as the Trow Rock Disappearing Gun. The actual weapon we see today is a replica, placed there in 1987. The original gun was installed in around 1887. It is disappearing in the sense that its experimental mounting platform allowed it to be raised and lowered within the concrete gun pit; however, it was never actually used in action. The system, which appears to have been both hydraulic and pneumatic, was ultimately unsuccessful and it was discontinued at Trow Rock, with a new battery being constructed a short distance down the coast at Frenchman's Bay in 1903. The magical photograph below shows the replica gun as dawn breaks.

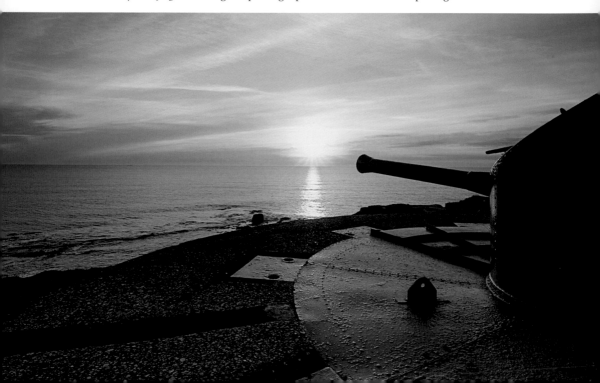

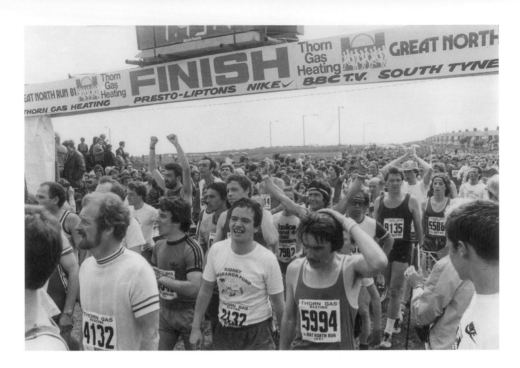

Great North Run

The world's greatest half marathon covers 13.1 miles from Newcastle, across the iconic Tyne Bridge and on to the stunning coastal finish in South Shields. Live music, on-course refreshments and thousands of cheering supporters keep runners motivated every step of the way. Less than 5,000 runners were expected to take place in the inaugural race, held on Sunday 28 June 1981, and so organisers were astounded when over 12,500 applied and over 10,000 of them completed the first ever Great North Run. Lots of people have their photo taken with the *Running Man* at the New Crown pub roundabout. For the run he is dressed in a vest and running shorts and at Christmas he is bedecked in his Santa suit, ready for the festive season.

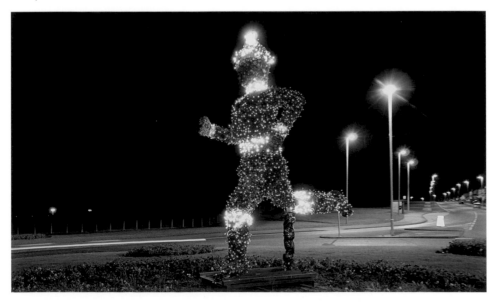

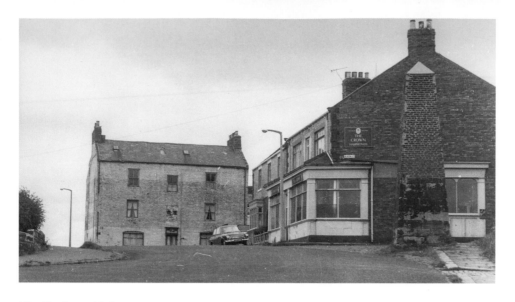

The Harbour Lights

The Harbour Lights pub stands majestically on the Lawe Top, commanding a fantastic view of the harbour. Before its name changed the pub was known as the Crown Inn. Weathered remains of lettering on the tiled roof can still be seen today. The large brick beacon can be seen on the right of this 1960s image of the Lawe. Another beacon is out of shot on the left. Ships would line the two beacons up when crossing the Tyne Bar to enter the river safely. This was before the piers were built and the river dredged. Trinity House conceived the idea of the beacons towards the end of the eighteenth century. Pilots would gather and wait to sail their cobles out to navigate vessels safely in to the mouth of the river. Lawe House, formerly known as Cross House, was originally built as barracks for troops and can be seen on the left of the image. At the time of writing, the pub has had a grand refurbishment and offers a stunning view over the harbour with floor to ceiling windows.

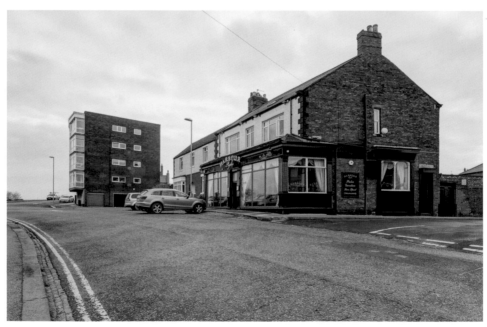

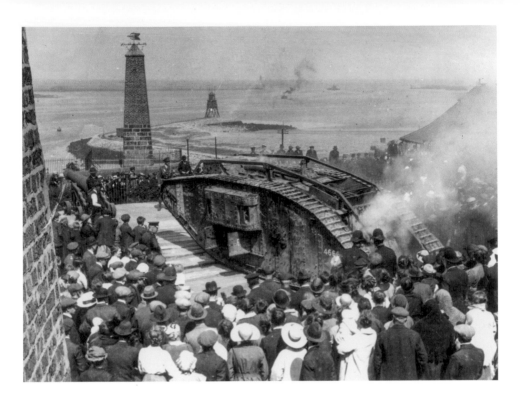

The Lawe Top
Huge crowds gathered to see this First World War tank, accepted by the mayor of South Shields, Thomas Sykes. It was given by the War Savings Committee chairman, Alderman Taylor. The tank was placed on the Lawe Top in an enclosure and famous local photographer, James Henry Cleet, captured the event in the summer of 1919. The Victorian image below shows the beacon to be somewhat taller than the above beacon.

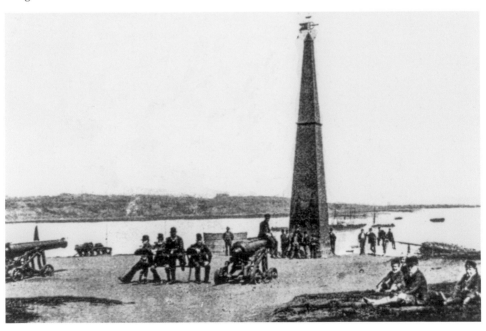

Arbeia Roman Fort

Arbeia was a key frontier outpost of the Roman Empire, being a supply base for the seventeen forts along Hadrian's Wall. Built around AD 160, it is of international significance and currently an English Heritage asset. Arbeia is the best reconstruction of a Roman fort in Britain and offers visitors a unique insight into the everyday life of the Roman army, from the soldier in his barrack room to the commander in his luxurious dwelling house. The museum, in its earliest stages, was opened in the summer of 1953 by Sir Mortimer Wheeler, Professor of Archaeology at the University of London. The opening marked the first post-war museum to be erected in the country. The Jude's postcard (*below*) shows local housing before it was demolished to uncover more ancient remains.

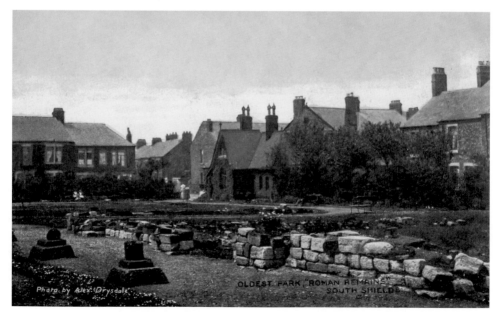

Trinity Tower

This watch tower was erected by the master and brethren of Trinity House, Newcastle, in the first half of the nineteenth century. The tower provided a good vantage point to see ships sailing towards the harbour. Note the crest with the anchor on the tower: it bears the motto in Latin *'Deus Dabit Vela',* or 'God will give the sails'. The Tyne pilot families, the Purvises, Marshalls and Boneses mostly lived on the Lawe, which was close to the Pilot Stairs and gave access to the river. After its closure around 1950, students from the Marine and Technical College undertook radar training there. The author was on the Lawe with her grandmother in the 1970s when a stone shrine was unveiled, marking the site of the tower. The crest with the anchor was saved and now has pride of place on the shrine.

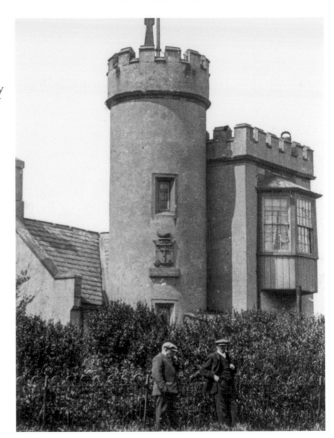

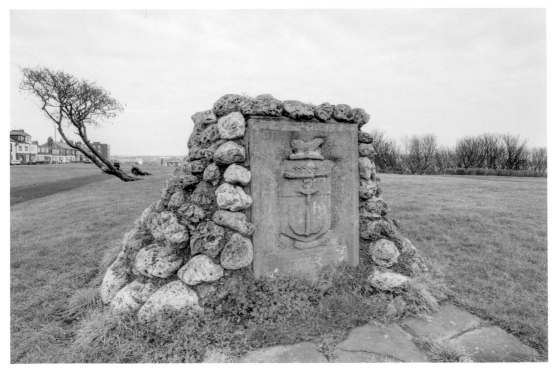

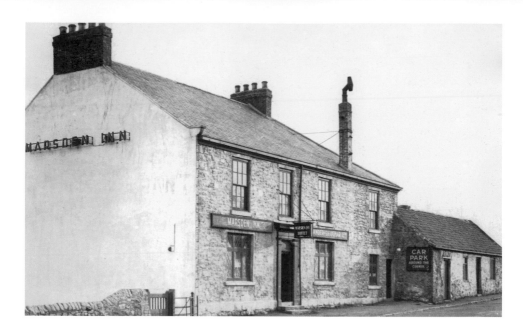

The Marsden Inn

These images show the old Marsden Inn on Lizard Lane in the 1930s, and the new Marsden Inn, Redwell Lane, as we know it today. *The Inn Guide to the North East 1984* describes the inn as 'a large mock Tudor style coastal hotel standing fully detached just 200 yards from the sea. The Tudor style is retained in the Green Room and Blue Room lounges and the bar, which offers darts and dominoes. There are two jukeboxes and folk music and country and western events are held three times a week. Ten bedrooms are available on request at £6.50 for a single and £13.00 for a double! Tasty sandwiches are available and inexpensive bar meals are served at lunchtime from Monday to Saturday. Special, three-course Sunday luncheons are available at £2.30.' Great value! At the time of writing the hosts still offer a fun and lively atmosphere with live bands, entertainment, buskers and a little bit of karaoke, if you fancy a sing-along.

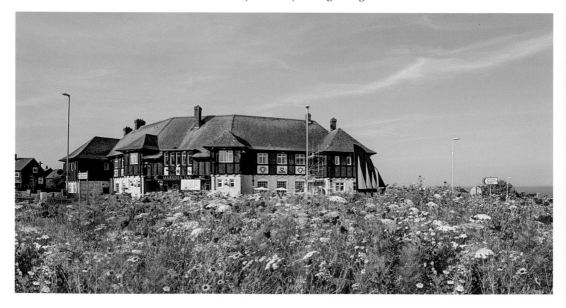

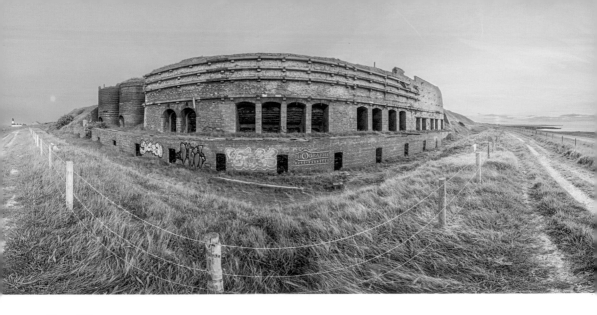

Lime Kilns

The kilns were built around the 1870s and form a great part of our industrial heritage. During the last century, lime was conveyed from them in carts to the old Stone Quay near Mill Dam at South Shields, from where it was shipped. Possibly a source of curiosity for drivers along Coast Road, the kilns are in a state of disrepair. The Marsden Lime Kilns site is a Scheduled Monument of National Importance – one of only three in the borough, alongside the Arbeia Roman Fort in South Shields and St Paul's monastery in Jarrow. In the 1980s there were proposals for the council to negotiate with British Coal to acquire the kilns under its conservation budget. It was also proposed to illuminate them. The owner of the kilns in the last century was a man known as 'Old Smokey'. Only a small man of 5 foot 4 inches, he was known for his constant pipe smoking. As legend has it, he had bow legs as a result of him falling into the kilns when they were alight and breaking them both. Poor 'Old Smokey'. Further along the coast is the locally renowned 'White Horse'. Many tales abound about how it came to be there.

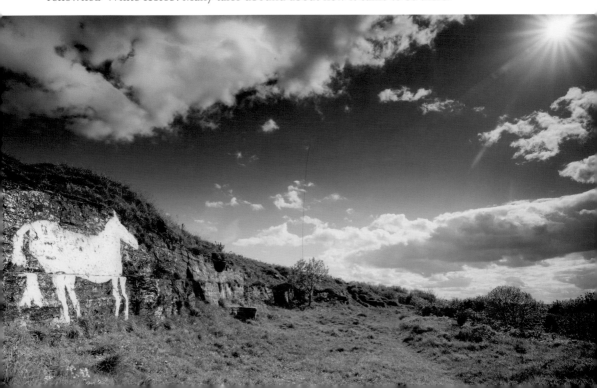

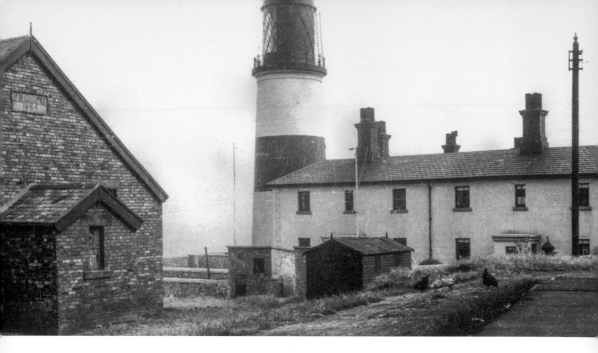

Souter Lighthouse

A marvel of its age, Souter Lighthouse remains an iconic beacon. It was designed by Sir James N. Douglas for Trinity House in London. It opened in 1871 and was the first lighthouse in the world designed and built to be powered by electricity. With its red-and-white livery, it stands prominently on the coastline between the River Tyne and the River Wear. Souter is a special place all year round and is Grade II listed. At 75 feet high, the tapered tower has square window openings to allow a light to be seen from the entrance to the River Wear. If you are brave enough there is an overhanging walkway with iron railings after you have climbed the steps. The views are amazing and well worth the ascent. Standing on Lizard Point, she was named after Souter Point, the next point southerly, to avoid confusion with the Cornish Lizard Lighthouse. North East heroine Grace Darling's nephew, Robert, was a lighthouse keeper at Souter for twenty-four years from 1873 to 1897. He lived there with his wife, Isabella, and their four children, James, William, Jane and Isabella.

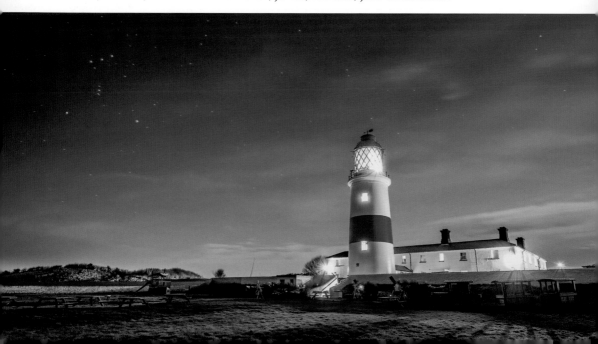

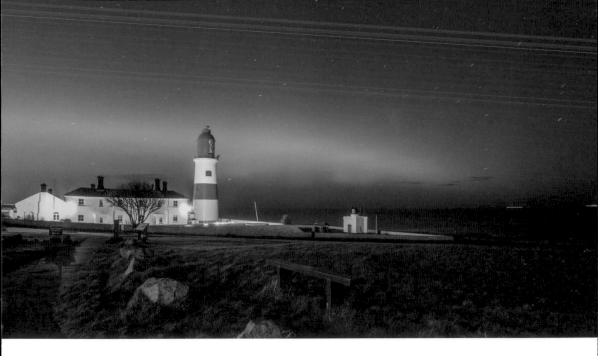

Aurora at Souter Lighthouse

These rare images show the *Aurora borealis,* or Northern Lights, as seen from Souter Lighthouse. The image below overlooks the entrance to the Tyne. An aurora is a natural light display in the sky (from the Latin word *aurora*, 'sunrise' or the Roman Goddess of Dawn), predominantly seen in the high latitude regions. Auroras are caused by charged particles, mainly electrons and protons, entering the atmosphere from above, causing ionisation and excitation of atmospheric constituents and consequent optical emissions. These fabulous, rare images were used in the making of TV programme *Britain's Wildest Weather*, which aired in 2014.

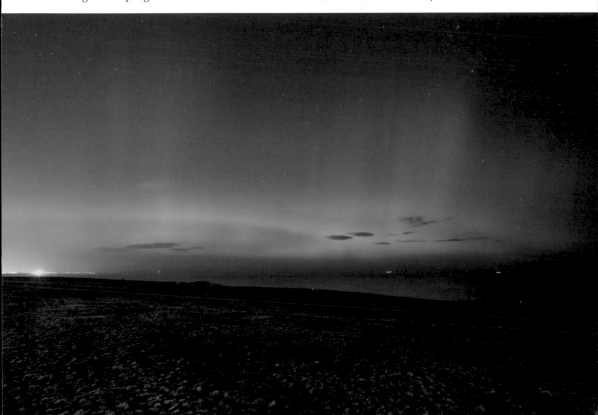

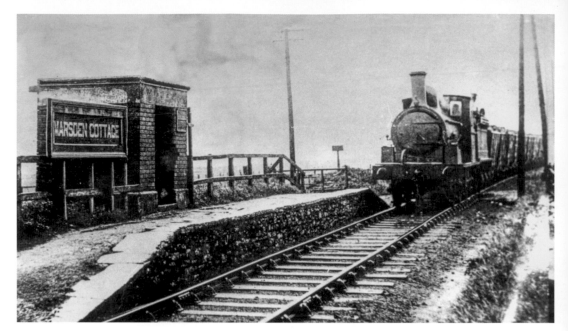

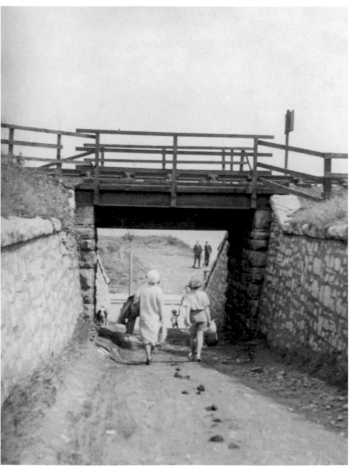

The Rattler
The train earned its nickname as the 'Rattler' as it used to rattle along the rails at high speed. Here it hurtles past Marsden Cottage station. The rickety old bridge over Redwell Bank does not look fit for purpose as folk saunter down to Marsden Bay. The road has been widened and running down it today means competitors in the Great North Run are not too far from the finish.

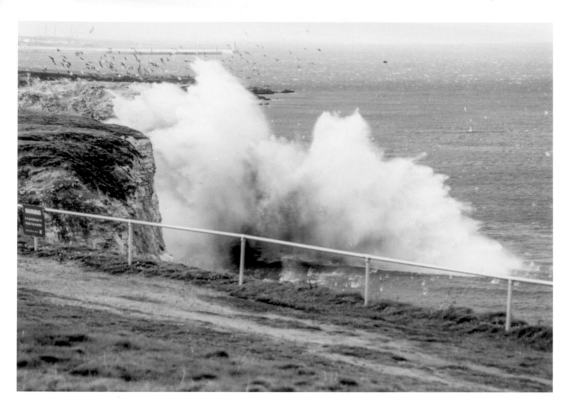

Marsden Rock

The famous arch of Marsden Rock collapsed due to severe weather conditions and the image above shows the smaller remaining stack being blown up due to health and safety advice in 1996. The image below shows a calm day and a view of the mighty stack. Can you see a face in the rock?

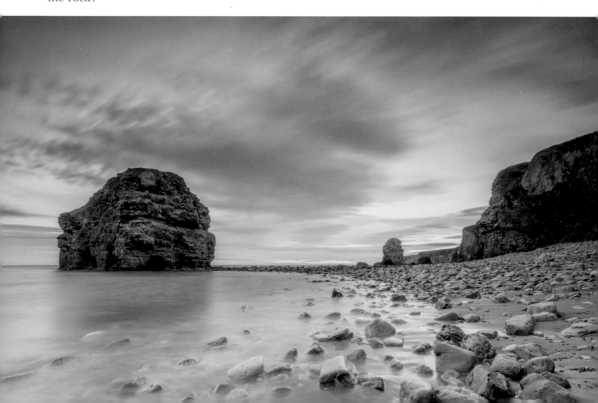

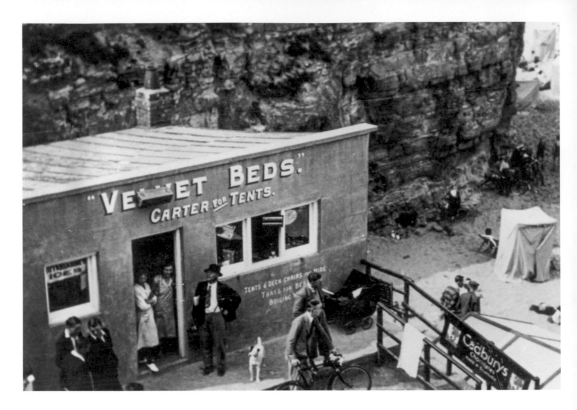

Velvet Beds

Carter's tent and deckchair hire at the Velvet Beds at Marsden. They offered tea trays for the beach, confectionery, cigarettes and ices. Everything you could need for a nice day on the sands! Concrete steps were later added, with complaints that the depth of the step was not consistent with an average stride.

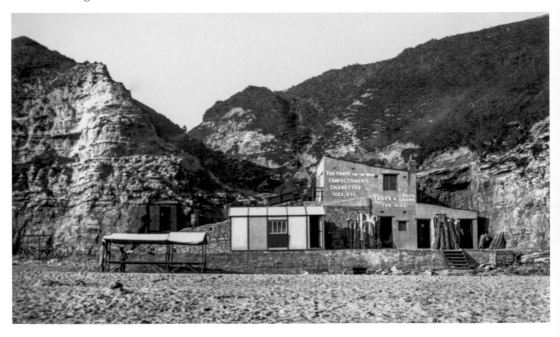

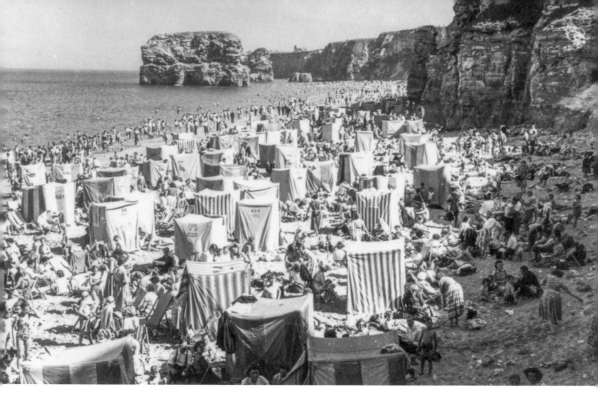

Marsden Bay

This black-and-white image shows how popular Marsden beach was back in the 1950s and '60s. Dozens and dozens of striped tents are crammed on the beach and there seems to be hundreds of children. It's a wonder they ever found their parents again after a dip in the sea. Nowadays this rugged part of the coast has become a magnet for photographers from far and wide.

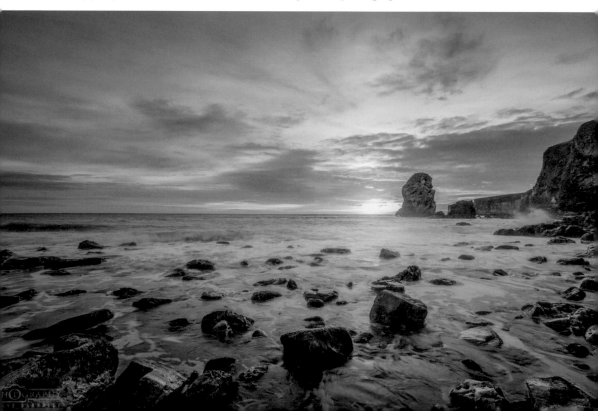

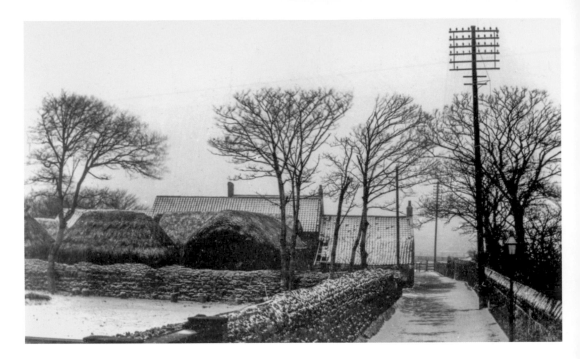

Colley's Farm

It is hard to imagine a farm in the centre of South Shields, but this one was owned by the Colley family for over 100 years. Hay stacks and leafy trees look south towards Grosvenor Road. A farm has been on this site for over 300 years and its pond and ducks brought children flocking down the lane in the summer months. Before Colley's or South Farm was built, the lane led through Wilkinson's farmyard, Meadowcroft and Ivy House, which were part of the original farm buildings. Time has moved on but the five trees in the centre of these images remain a constant from Colley's farm to the present day.

Wyvestow Lodge

This image shows Mr T. H. Allan sitting proudly in his car outside Wyvestow Lodge. Mr Allan was a local baker and his three-wheeled vehicle advertises his business. Crumpets, muffins, milk cake and Melton Mowbray pies were all on offer. Today the lodge still stands proudly but serves a somewhat different purpose – students of nearby South Tyneside College can rent accommodation, provided by Brown's Letting Agency.

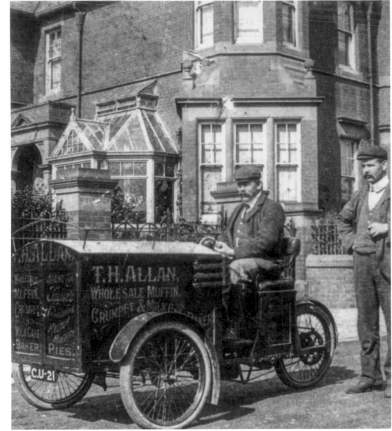

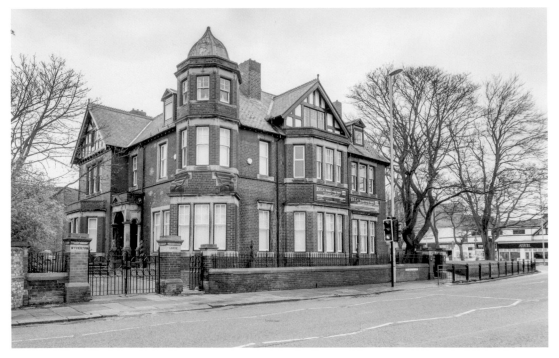

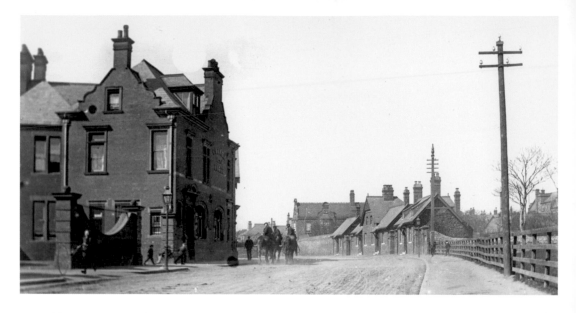

The County Hotel

Here is an Edwardian image of the County Hotel. This pub stands on the former site of the Westoe Tavern. The former coaching inn would have been a welcome break for travellers between the towns of Sunderland and South Shields on the Harton Road. This view is looking towards Westoe Village and shows the area behind the fence that was to become the Marine and Technical College in the 1960s. It may even have been Colley's farmland. The pub (*below*) has been extended and is still a most popular hostelry.

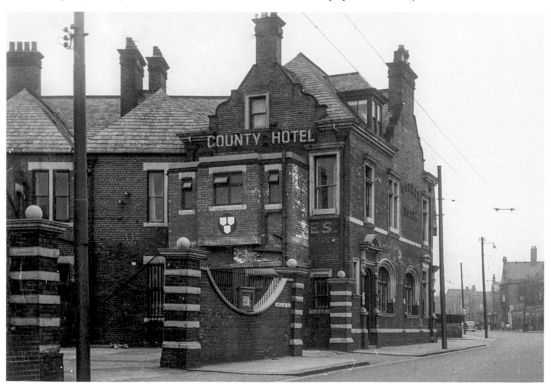

Sir William Fox Hotel

The first recorded mention of Westoe Village was around 1072, when it was originally thought to comprise half a dozen farmhouses. Derwent Lodge, Westoe Hall, the White House, Chapel House and Ivy Cottage are thought to be sites of these original farmsteads. Designated as a conservation area, the village remains very exclusive. William Fox was born in 1812 at No. 5 Westoe Village – now known as the Sir William Fox Hotel. Shortly after qualifying to practice as a lawyer, Fox married Sarah Halcomb. There were great things ahead for William when they sailed to Wellington in New Zealand. After leading the revolution that unseated PM Henry Sewell, he was appointed prime minister in 1856. Subsequently, he was in office on three other occasions. Ngataua Omahuru was a small Maori boy whom he adopted and later gave the name William Fox Jnr.

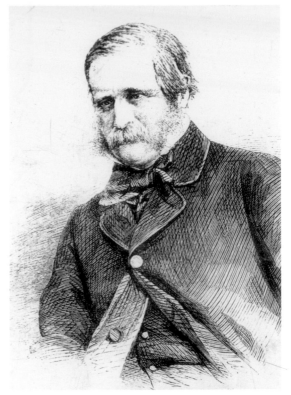

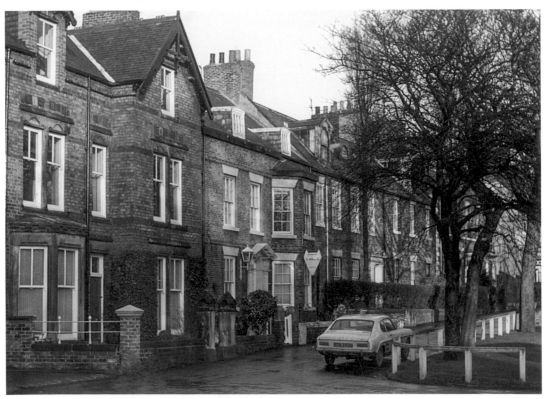

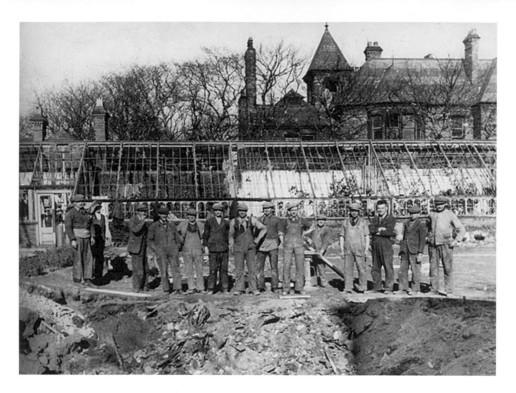

Eastgarth, Westoe Village

This black-and-white image shows extensive bomb damage to the gardens of Chapel House in Westoe Village. Local historian and photographer Amy Flagg lived there with her parents. The damage was caused after a bombing raid on the town in April 1942 during the Second World War. The glasshouses behind have been shattered and to the rear Eastgarth can be seen. Around a dozen cloth-capped men look on waiting to start work on the bomb damage. Eastgarth has long gone but the remains of the gateposts at Eastgarth Lodge can still be seen. This is the view from Grosvenor Road (see map on page 4).

Fairfield House, Westoe Village

Fairfield House had the distinction of belonging to one of the shipbuilding barons, Joseph Middleton Rennoldson of J. P. Rennoldson's. He lived there with his family until his death, around 1916. He was mayor of South Shields twice in the 1890s. Rennoldson's eldest daughter Marion and her husband Charles Ross occupied it later. With the closure of the shipyard in 1926 they moved away from the town and George Readhead moved from neighbouring Seacroft into the house. Towards the end of its days the house stood empty, was deemed unsafe and was demolished shortly after the Second World War. The splendid trees that lined the drive are still there today. This view is also from Grosvenor Road (see map on page 4).

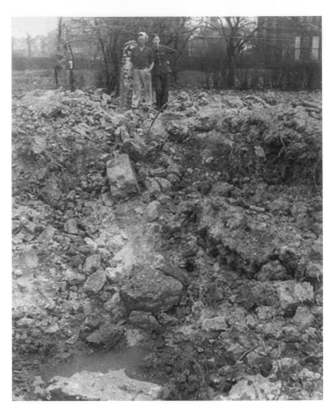

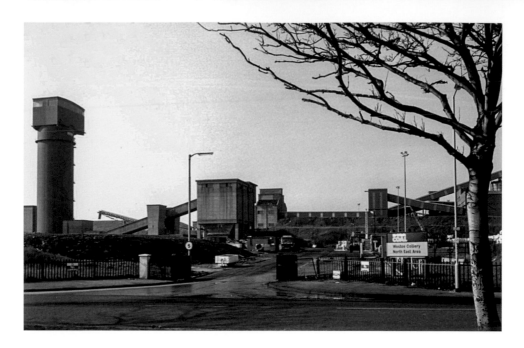

Westoe Colliery

This 1980s image shows Westoe Colliery and is now the site of Westoe Crown Village. Eighty-four years of mining came crashing down in June 1994 and the colliery buildings were demolished. A flagship urban village was to rise from the ashes. Westoe Crown Village was expected to take five years to complete and would have 580 new homes, a new primary school, community centre and retail units. The street names are interesting: Baltic Court, Sea Winnings Way, Greenside Drift and Brass Thill Way, to name a few. They are seemingly names of the coal seams underground at the colliery and under the North Sea.

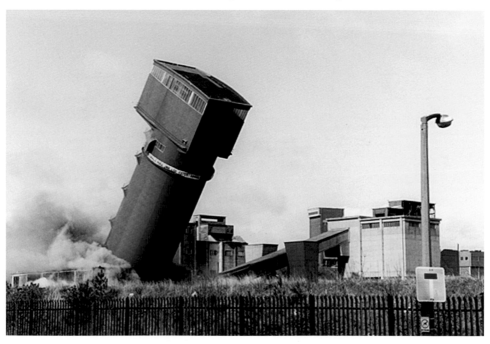

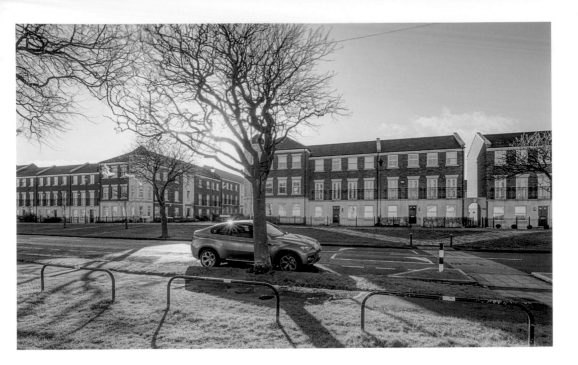

Westoe Crown Village

This front-facing Victorian-style terrace commands fantastic views over the 'dragon' and our stunning coastline. A pedestrian entrance to the village appears to be the same as to the colliery, all those years ago. Over the last few years, this windswept tree has come to be known as the 'shoe tree'. Several pairs of laced up shoes and boots can be seen adorning its branches after the leaves have fallen. Who knows why?

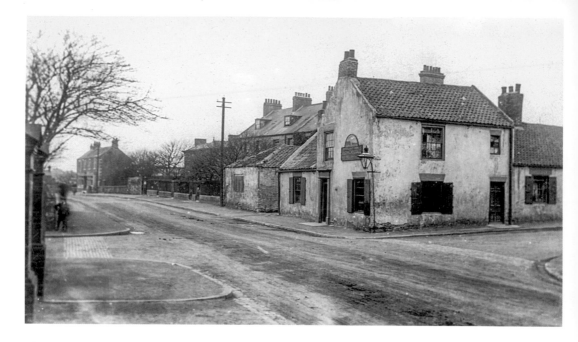

The Vigilant

Times in Harton Village have changed and so have the pubs. The demand for a drink is as great as ever but the spit and sawdust interiors are as much part of the past as horse-drawn carriages. Perhaps continental holidays were responsible but in the 1960s people wanted a pub that was a little bit different. In 1967, Mr Ron Bell decided to give a Spanish theme to his pub, The Vigilant, and the Torero Lounge was born. A quite real bull's head and a mural of a Spanish village helped to create the ambience of a Costa Brava holiday! The conversion took almost six weeks and cost almost £3,000. The image above is from the 1920s and the one below possibly from the 1940s.

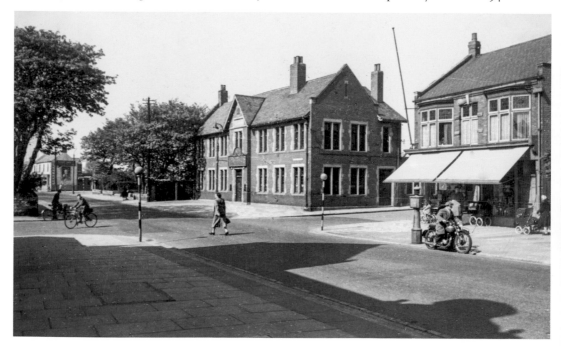

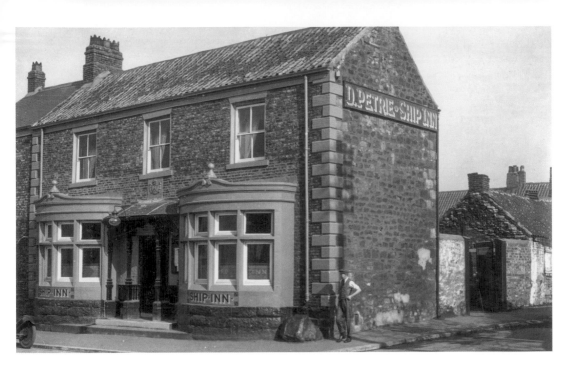

Ship Inn

At Harton Village, the Ship Inn is rumoured to be one of the oldest pubs in the town. Local photographer James Cleet took this photograph in the 1930s when the licensee was D. Petrie. The entrance at that time was between the two grand bay windows. Over the years extensions have been added. The crest above the door is thought to be from the nearby blacksmith's and is dated 1803: 'By hammer and hand all art doth stand'.

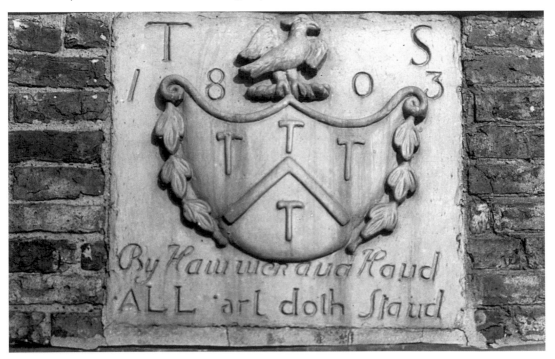

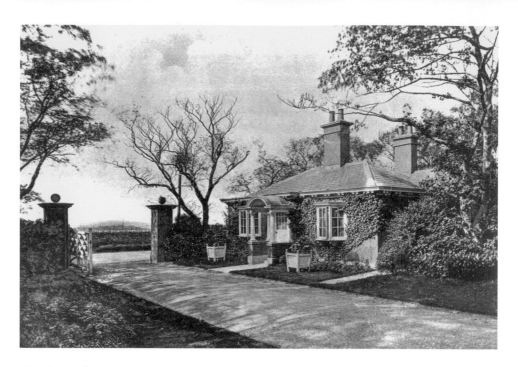

Cleadon Park Mansion
This quaint lodge was at the foot of the driveway up to the mansion house. The grand house was renowned for its glass palm houses. Foliage headed skywards and dwarfed the cane furniture.

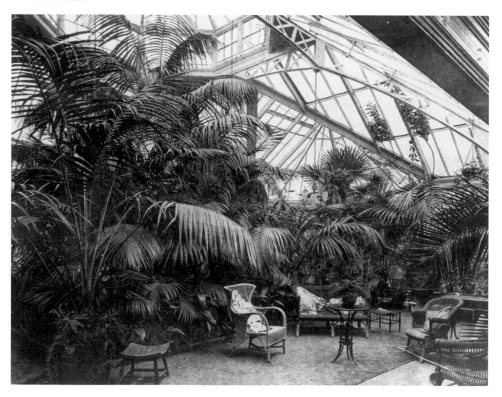

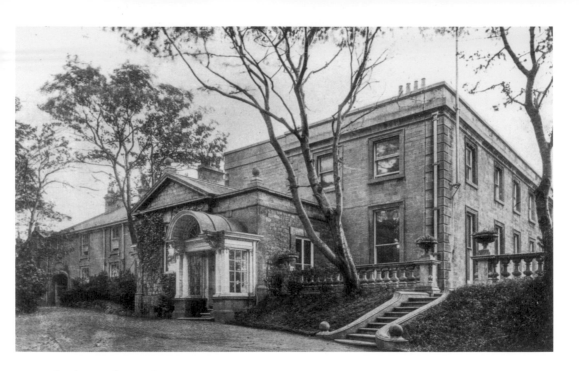

Cleadon Park Mansion
The original building was an old farmhouse that was converted into a mansion in the Classical style by John Dobson in 1845. It later became a sanatorium in 1922, treating people with tuberculosis. The driveway survives and now leads up to a prestigious estate of forty-three houses, known as Parkshiel. Whether these steps are in exactly the same place remains a mystery.

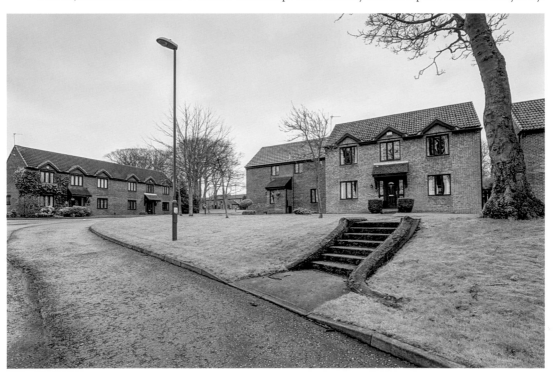

South Shields: The Postcard Collection
Caroline Barnsley

This fascinating and humorous selection of postcards traces some
of the many ways in which South Shields has changed and been
depicted over the last century.

978 1 4456 3446 3

96 pages, full colour